# Colour on Cloth

# Colour on Cloth

## Ruth Issett

BT Batsford

First published 2004

© Ruth Issett 2004

Volume © BT Batsford 2004

The right of Ruth Issett to be identified as
Author of this work has been asserted by her
in accordance with the Copyright, Designs
and Patents Act 1988.

ISBN 0 7134 8901 4

A CIP catalogue record for this book is
available from the British Library.

Photography by Michael Wicks.

Printed in Malaysia

for the publishers

B T Batsford
The Chrysalis Building
Bramley Road
London
W10 6SP

An imprint of **Chrysalis** Books Group

# Contents

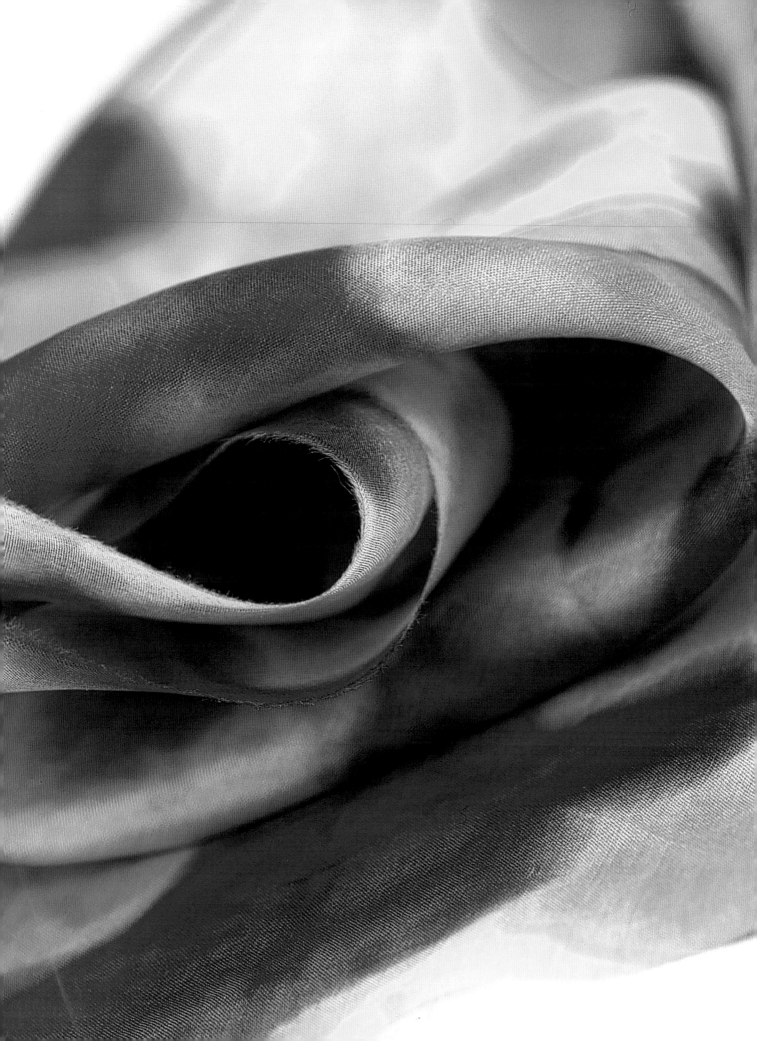

# Introduction

How do you explain to the uninitiated what it feels like to be hooked on colour? And how can you best describe how to combine inspiration with some straightforward techniques to create a wealth of patterns and effects by applying coloured dyes to fabric? Whenever you begin to prepare a piece of fabric for dyeing, there is an air of anticipation of lovely things to come. Initially, there is always the feeling of trepidation when the brush first touches the fabric and the dye starts to pigment it. Will it be the colour I imagined? Will it go where I want? Will it stay there? Will it turn out as I have planned? Then there is that exciting moment when a dyed parcel is unwrapped, revealing a gloriously patterned fabric, all because you tied it in a certain manner. Equally, after you have rinsed, washed and ironed what seems like a hundred different pieces of fabric, you can lay them out in colour order on a table to produce a sight that makes all your efforts truly worthwhile.

This book will allow your creativity to take flight, giving you the foundation to colour a wide range of fabrics with confidence. There are suggestions of ways to record your ideas and inspirations, plus guidelines on how to put them into practice. It provides tips on colours, clarifies dyeing, thickening and resisting techniques, and includes some key recipes.

*Opposite page: Pattern-dyed silk habotai.*

# Chapter One
## *Colour and colour mixing*

1

*If you are really serious about trying dyeing and learning about colour, then you need to invest both time and money. There is no shortcut to producing exciting colour. We all start from different points, have a set of different experiences and have had different opportunities. Don't let that worry you. The important thing is that you want to look at the colour in this book and hopefully you can't wait to get going yourself. The only real way to learn about colour is to use it.*

# A rainbow of colours

The first step is the actual selection of dye colours. So many people still believe that you only need to buy one red, one blue and one yellow to create the full spectrum of colours. In fact, you need a minimum of six colours.

*Page 8: Paper collage using papers painted with Procion MX dyes.*

*Below: Using basic dye colours to mix a range of varied shades.*

Your basic colour selection should include an acid yellow such as a lemon, an 'orangey' yellow such as golden yellow, a vibrant red like scarlet, a sumptuous red such as magenta, a rich blue such as ultramarine and a bright, lively turquoise. From this palette you will be able to mix hundreds of rich and beautiful colours and, with experience and a few recipes, get these colours onto fabric. Mixing colour is rewarding and absorbing; it is not something to be afraid of. Occasionally you will mix colours you don't mean to and colours you loathe, but through these failures you will learn which combinations don't work for you and to avoid.

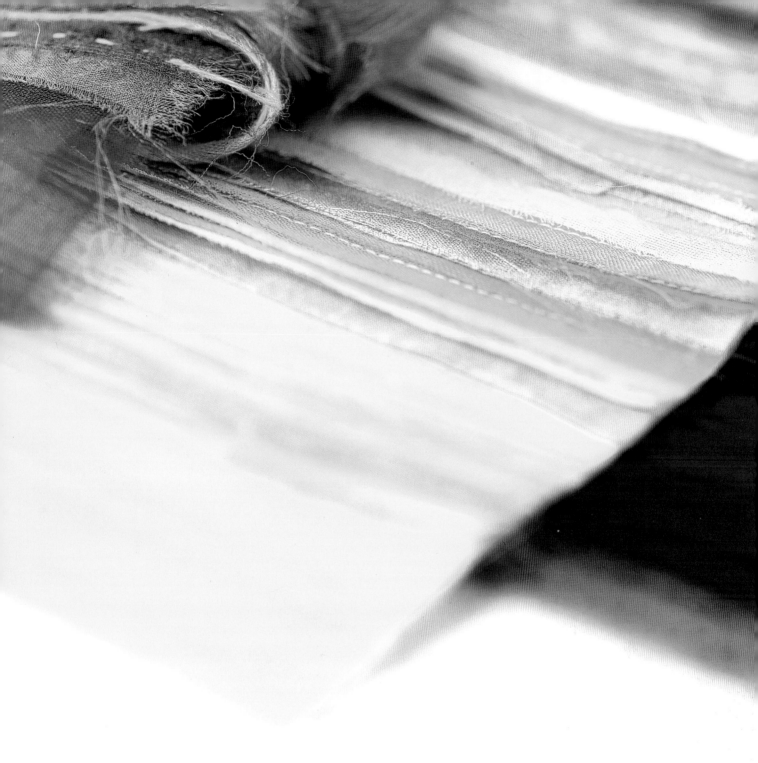

Once you have decided on these six basic colours, you need to get to know them.

Wearing a dust mask, place about a quarter of a teaspoonful of dye powder into a paint palette. Add about 25ml (1fl oz) of hot water and stir to dissolve the powder. Try each colour on some good-quality cartridge paper or watercolour paper or in a sketchbook. If the colour is too strong, dilute it further.

Have a pot of water to rinse the brushes regularly to prevent contamination of the pure colours, and some paper towels to dry the brushes so that the dye colours do not become diluted.

*Above: Procion-dyed cotton and silk organza, layered and stitched.*

Now the fun begins. Try mixing the following combinations and recording them in your sketchbook together with labels and details for each. It will be difficult to find names for all the colours that you make, so try to associate the colours with memories of things you have seen.

• Try lemon yellow with a little turquoise to achieve a lime green. Add more turquoise to get an emerald green.

• Mix turquoise and a little lemon and see how quickly it turns to an aquamarine. Add more lemon and it becomes a bright spring green.

• Golden yellow and a little turquoise will give a totally different green – an orangey, slightly olive colour will appear.

• Try different combinations of lemon yellow and golden yellow, adding varying amounts of both turquoise and ultramarine to see how many greens you can make.

• Now move on to trying golden yellow with scarlet to create a set of oranges. Take care, as it is very easy to drown yellows with reds and difficult to produce a subtle range of oranges.

• Try lemon yellow with a very small quantity of magenta. Note that magenta is very powerful; sometimes it is worth making it weaker so it does not overpower more lightweight colours.

By now you will have sheets of yellows, greens, reds and oranges but there will be a lack of blues or violets. These are always the most difficult to mix as they are so dark and it is difficult to see how much the colour is altering.

• Mix ultramarine and magenta together, trying different quantities of each. When they are dry you will find that you have made a series of mauves, violets, purples, aubergine and burgundy.

• When adding magenta to turquoise it is possible to make a greater range of blues and mauves than with ultramarine, which is so powerful.

• Mixing scarlet and ultramarine can be difficult. Begin with scarlet, as it is lighter, and add a very small amount of ultramarine. A lovely range of deep rusts and terracotta can be developed provided the ultramarine is not allowed to dominate.

• When mixing turquoise and scarlet, try adding scarlet to turquoise as well as turquoise to scarlet to create two completely different ranges of browns and greys.

Some of your trials will bleed together; sometimes you will make too big a step and find that the colour has changed more than you intended. Remember it doesn't matter: this is for you, your reference, your own knowledge.

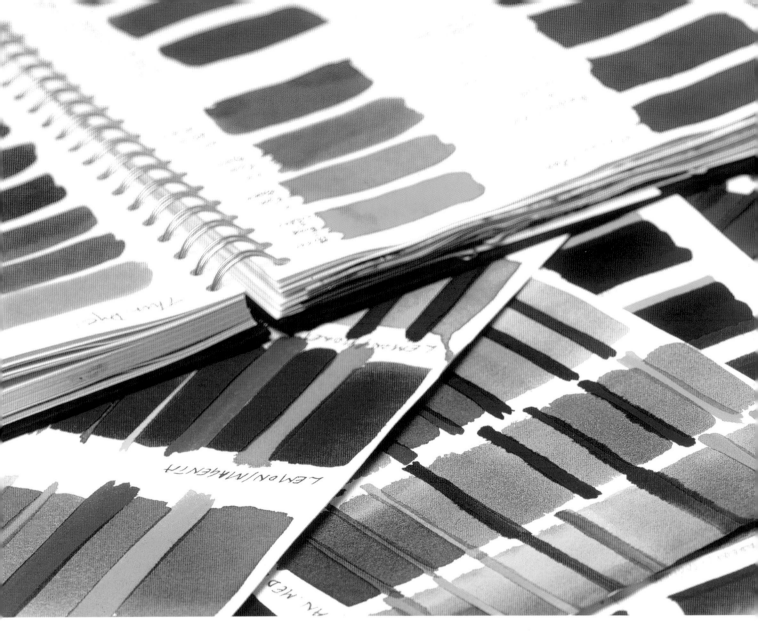

## Contrasts and complementaries

The use of a complementary colour can be invaluable when you want to give a lift to a colour scheme. It can act like a sprinkle of spice, seasoning or sugar in cooking by providing a sharp contrast with a particular colour, thus enhancing it.

Complementary colours are those that appear on opposite sides of a colour circle. Each complementary pair contains a balance of the three primary colours, red, yellow and blue. A simple way to remember how they are recognized is to take a secondary colour and work out what colours you need to mix it. The one that is missing will give you your complementary, For example, green is made from blue and yellow, so the complementary is red. Similarly, the complementary to orange (made from yellow and red) is blue, and for violet (made from red and blue) it is yellow.

*Above: Sheets of dye colours mixed on watercolour paper to explore the ranges of colour.*

*Above:* Photograph of cordylines showing a wide variety of different-coloured leaves.

Remember that there are many different shades of all these colours. In your sketchbook try painting strips with spaces between them in greens, violets or oranges. When these strips are dry, try different complementary shades between them. Try a range of reds with the greens, a range of yellows with the violets, and blues with the oranges. Observe how one colour will alter another. A clear, bright orange can look quite rusty when placed next to a lively aquamarine, and a turquoise can look more green when placed between orange stripes. The more you mix, the more ideas for different combinations will occur to you, and all the time you are increasing your knowledge about colour mixing.

## Additional colours and creating families of colour

The six basic colours can give a very versatile colour palette. However, there are a few others that will be a useful addition to your collection. You can make these colours from your initial six, but it is not always easy to get the exact same colour each time you need it.

These colours are an orange, an emerald green, a violet, tan, dark brown and a black. Dye suppliers use different names for the specific colours: check the dye chart on page 34 to help you select the specific names.

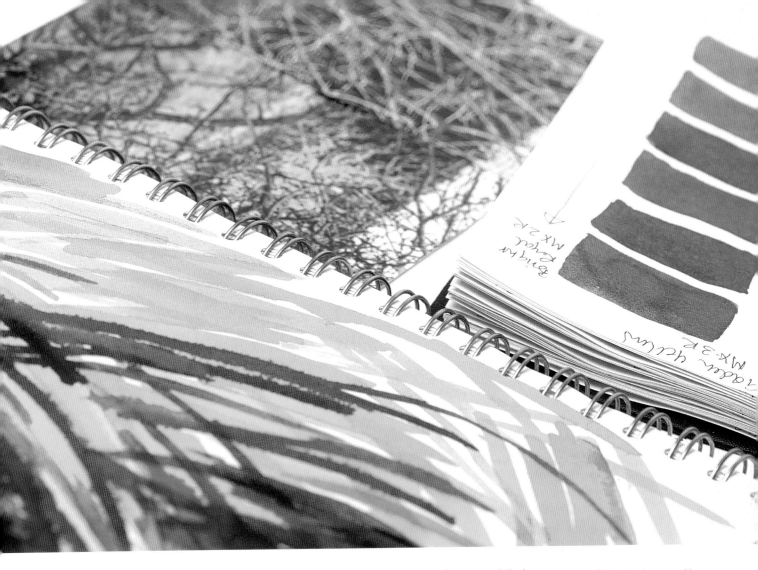

*Above: Sketchbook page with photographs and paintings based on dogwoods, and dye book colour trials.*

Families of colour are described in detail in the dyeing section (see page 69). A family is made up of the gradation of shades between two main colours. The most obvious family is that between lemon yellow and turquoise where the colours begin at lemon, move through limes to acid greens and sharp bright green, emerald green onto jade green then aquamarine and finally to turquoise. That journey is fairly simple to follow; it is easy to see the colour change quite distinctly. Lemon yellow is a very aggressive colour: it will stand its ground and is not easily dominated by the turquoise. It may be difficult to get beyond emerald green by adding turquoise to yellow, so try the other way round; by adding a little lemon to turquoise, you will achieve a sparkling aquamarine.

Be prepared that, like all families, there will be those members who dominate, those who are quiet but forceful, and those who don't seem very interesting initially but given time become absolute stars. Try more striking or unusual families, either on paper or later on fabrics. Paint each shade in a small square, leaving a space in between, so the colours do not run into each other. Write down the name of the first colour and at the end the second colour and also indicate which way you mixed the colour. You may think you will remember all these details, but it is amazing how quickly you forget. You will quickly build up a sketchbook bulging with useful colour recipes that grow in subtlety and sophistication as time goes by.

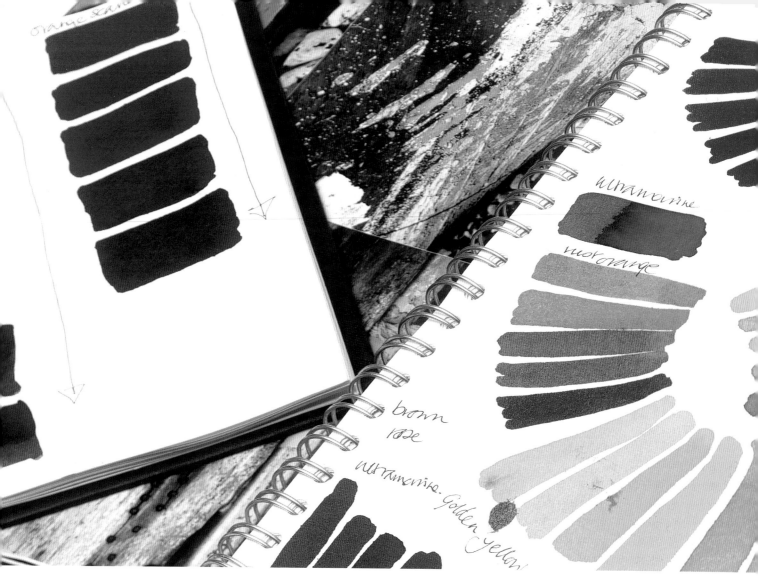

*Above: Sketchbook pages with boat pictures and dye-book page showing colours mixed prior to dyeing on fabric.*

Try some of these colours together. As a general rule, start with the lightest colour and add the darker one to it.

Dark brown mixed with blues, scarlet or greens give a muted collection of soft, warm colours. Rust orange and scarlet make a range of soft peaches, terracotta, sand and rust colours that might be found in an old wall.

See how black affects blue, red or yellow. Many people are surprised when they find that yellow becomes green!

It is worth giving yourself time to experiment with colour and documenting your trials. Sketchbooks full of colour ideas are always invaluable when you feel completely devoid of inspiration at a later date. Also, the actual mechanical process of mixing colours, watching the change from one colour to another, is all good practice, increasing your knowledge of how colours are achieved. The occasional accidental drop of dye falling in the middle can surprise you with a new colour combination. Overindulgence is not a sin in this instance: a diet of colour certainly isn't fattening and surely feeds the soul!

# How, what and where?

So where do ideas for designs and colour come from? For me, it is a combination of things but mainly the constant observation of colour and the effects of different light qualities. It is also the opportunity to mix colours together repeatedly, not only with dye but with printing colour, acrylic paints, coloured crayons, oil pastels, wool fibres and fabrics. Experiences are constantly logged away in the brain and are retrieved, revisited and developed. Do not rely just on the memory, however. If possible, try to record a colour by mixing it and applying it to paper. Photographs are useful, but rarely give a true representation of the colour as you saw it. If you do a quick colour sketch you will spend more time personally observing the colours, mixing them and perhaps discovering additional colour combinations.

## Selecting ideas

In deciding to write this book, it seemed important to consider selecting some particular ideas to explore. However, this became increasingly difficult as I got into the project. Recognizing that part of my character is continuously collecting, trying different things, investigating the 'what if' and enjoying sharing this information with others, means that lots of ideas are continually 'work in progress'. Yet occasionally, along the way, pieces get finished, decisions get made and the process of expressing ideas through colour is achieved.

*Below: Use artists' postcards for colour inspiration and paint colours in a sketchbook page.*

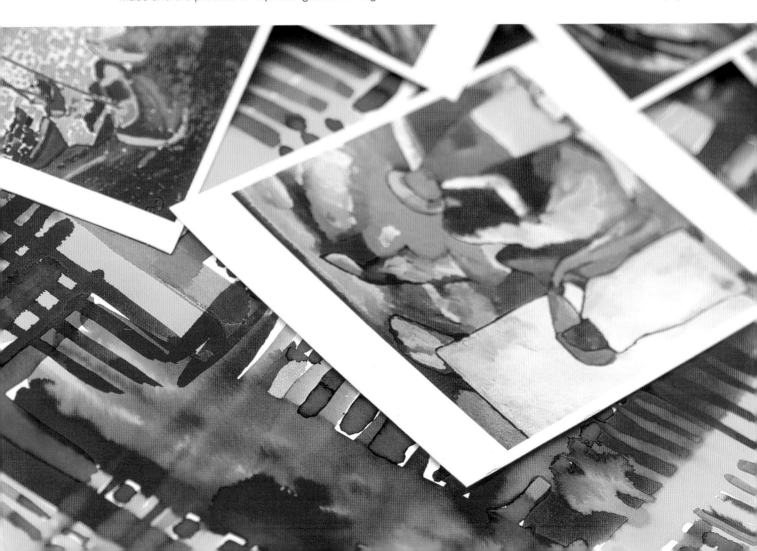

*Above:* Photographs taken in and around boats provided the inspiration for a simple painting using dye in a sketchbook.

Just look around you, out of the kitchen window. Watch the colours early in the morning, maybe on a frosty dawn. They are all pale greens, violets, greys, soft blues and browns. At another time in winter the sun is catching the bark of a shrub: is it brown or is it red or even purple? Observe the hedgerows at the same time of year. Although bare they are an amazing array of yellows, greens, browns, reds and purples. Plants can be an excellent source for inspiration. Study some of the wonderful books on garden plantings to get ideas for colour combinations. Visit nurseries and garden centres to look at all the different foliage colours in plants such as cordylines and coleus.

Colour is all around us, not just in nature but in the litter strewn in the street, the peeling layers of advertising hoardings. Supermarkets can be inspirational with their piles of fruit and vegetables, especially some of the more exotic varieties. In fact, I love shops that have multiples of anything such as tubs of sweets or accessories such as scarves, necklaces and bags. It is easy to collect scraps of wrappings, labels or cloth and add them to your sketchbook.

If possible, take the opportunity to go to an art gallery just to study a few paintings by well-known artists such as Kandinsky, Van Gogh, Matisse, Degas, Vlaminck, Klee, Gauguin, Seurat and Cézanne at first hand. How did they use colour, mix it, layer it up? Look at the quality of the colour, the surface of the picture – is it rough, chalky, smooth or shiny – and then think how you can use this when dyeing and painting papers and fabrics.

*Above: Sketchbook page showing an old barn in Scotland with an interesting stone wall.*

*Following page: Abstract design worked using Markal Paintstiks as a resist and Procion MX as an ink wash.*

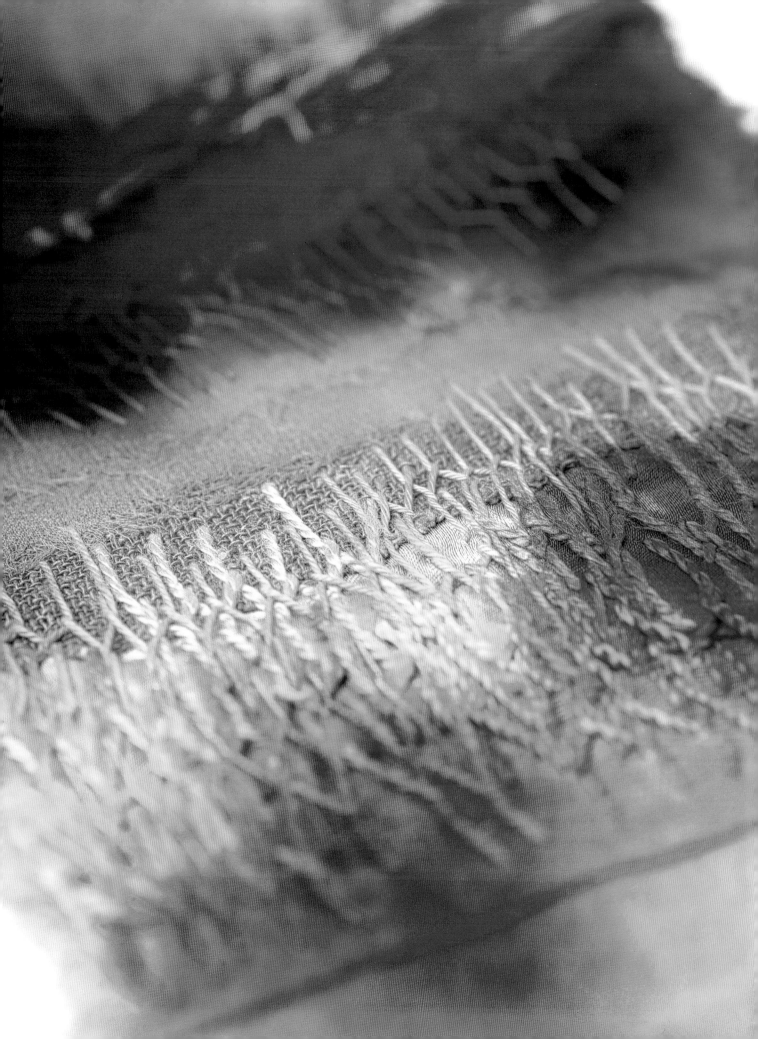

For many people holidays are a good opportunity to stand and stare, to draw, paint and photograph. They certainly have been for me. I particularly relish the opportunity to get to remoter parts of the coast such as western Scotland where the light is dramatic, and remarkable colours appear on walls, rocks and old buildings due to the extremes of weather. The notes in my sketchbook include blues, greys and grey/browns against russets, oranges and yellow ochres, with a touch of deep purples as well as warm brick colours. These references feed me so that when I prepare new papers and fabrics there is something to work from.

Another fascination for me has been old rotten boats, found both at Dungeness in Kent and in Scotland, with their weathered wood and fibreglass hulls, scratched and rusting, flaking paint revealing the sudden contrast of orange or ginger against bright blue to create that wonderful sizzle factor. In fact, my eye searches for that colour combination that gives richness and fullness to the view or to a piece of work. It may be the focal point or it may be on the edge, but without it the piece lacks something. I find that important when I am preparing design ideas. I often instinctively feel the need to add a certain colour, and as soon as I do the whole piece comes alive. Afterwards by studying the piece I will mask out areas of the design to assess whether it would work without the additional colour and, although it is often acceptable, the new colour makes the whole piece richer and all the more desirable.

Do not feel guilty that you are not working with a specific theme. You are allowed to just try any colour in any way you like, just as other people are allowed to spend hours organizing their threads or sorting their fabrics. By trying out the colours you are discovering what is possible for you and that is not wasting time!

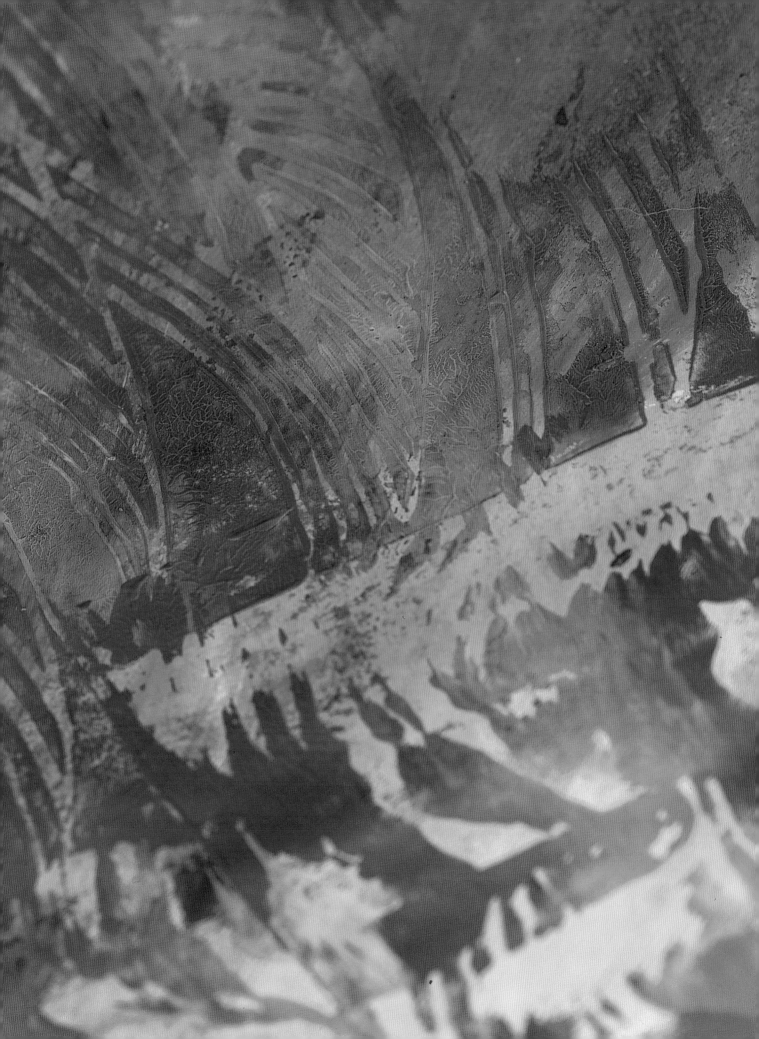

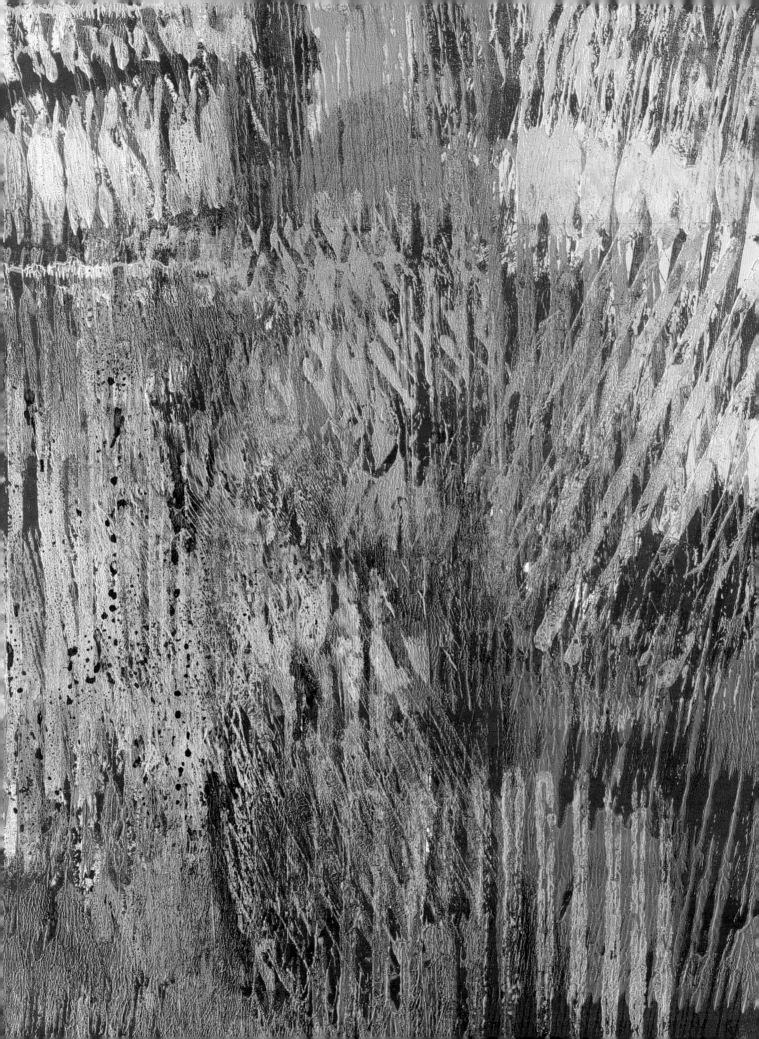

## Playing with colour

Finally try some of these ideas to explore your chosen dye colours further.

Make a collection of different white papers, from tissue paper to heavy-weight handmade papers and Asian papers. Paint strips of one colour onto them.

Drip the dye onto the papers, blot it, comb it, sponge it, let it dribble, let it puddle, then drop another colour into the middle of it and let two colours run into each other.

Use different brushes, sponges, sponge rollers and found objects such as corks to apply the colour to paper. Try out some design ideas taken from your collection of visual resources.

Use these papers to create colour collages using all blues, all reds, etc. It is a fascinating and very useful exercise. It makes you very aware of how the colour is absorbed into the paper. It also helps you learn which colours you prefer not to use and it sharpens your eye and makes you notice how colours will merge together as you get further away.

Look at my two other titles, *Colour on Paper and Fabric* and *Glorious Papers*, for further design ideas, techniques and methods and spend some time playing with some of those ideas.

*Opposite page: Exploring ideas and colour schemes using simple block prints and further inking with Procion MX dyes.*

# Chapter Two
## *Getting started*

*Procion MX dyes are recommended for all the techniques in this book. These are fibre-reactive dyes that can be used on cotton, linen, viscose, rayon and silk. They are comparatively easy to use, mix well and give lovely vibrant colours. Apart from dyeing fabric, they can be successfully used as ink on paper, thus creating the added advantage of enabling you to explore colour mixes on paper and reproduce them on fabric. Most of the techniques will involve applying the dye directly to the fabric rather than immersing it in a bowl or bucket, although some methods do include some immersion dyeing. Before commencing, however, it is important to familiarize yourself with the materials and equipment.*

# Materials

It is necessary to invest in a basic dyeing kit, to use equipment that is dedicated to your dyeing work and not kitchen utensils. The following items are essential.

## Equipment
- Measuring jug of 1 litre (1¾ pint) capacity with calibrations for millilitres (ml) and fluid ounces (fl oz).
- Smaller measuring jug or beaker, 250ml (9fl oz).
- Small liquid measure, 25ml (1fl oz) (often given with cough medicine).
- Plastic funnel.
- Set of measuring spoons: tablespoon (15ml), dessertspoon (10ml), teaspoon (5ml), ½ teaspoon (2.5ml). These are available in metal or plastic.
- Cheap, disposable plastic spoons for stirring dyes and dissolving dye auxiliaries.
- Radial palette, divided into 12 sections, each section to hold approximately at least 50ml (2fl oz) of liquid.
- Small plastic boxes, tubs or pots to hold mixed dyes.
- Plastic mixing bowls, small buckets or tubs.
- Conventional plastic bucket for immersion dyeing.
- Shallow, plastic, garden plant tray or window-ledge tray.
- Wooden spoons, for immersion dyeing, and wooden tongs.
- Medium-weight plastic sheeting for covering work surfaces and laying under fabric when painting. It must be stout enough to lay flat and firm. Some garden centres sell suitable polythene about 2m (6ft) wide.
- Kettle for heating water.
- Stout plastic bins with lids to store the dyeing equipment and the dye and auxiliaries, preferably in a cool, dry environment.
- Old electric kitchen whisk for mixing quantities of paste (useful, but not essential)

## Personal protective clothing
- Good dust mask, a box of dust masks that are replaced at regular intervals or a proper respirator.
- Rubber gloves, or finer surgical gloves that are easy and comfortable to wear for long periods.
- Laboratory coat or thick fabric apron.
- Safety goggles when using bleach or discharge pastes.

## Equipment for applying dyes
- Selection of sponge brushes, 2.5cm (1in), 5cm (2in), 7.5cm (3in) and 10cm (4in).
- Variety of sponge rollers, available from 1cm (½in) to 15cm (6in) in various weights of sponge as well as patterned rollers.
- Synthetic sable paintbrushes hold a reasonable quantity of liquid and are very good for painting fine line detail.
- Bristle brushes for when applying uneven quantities of colour. Household paintbrushes can also be useful.
- Pieces of natural sponge and textured sponges.
- Expanding sponge, available in thin, flat, compacted form, which can be cut and moistened to expand to three times its size.

*Page 26: Detail of silk muslin printed with thickened dye, showing how the dye can colour individual threads.*

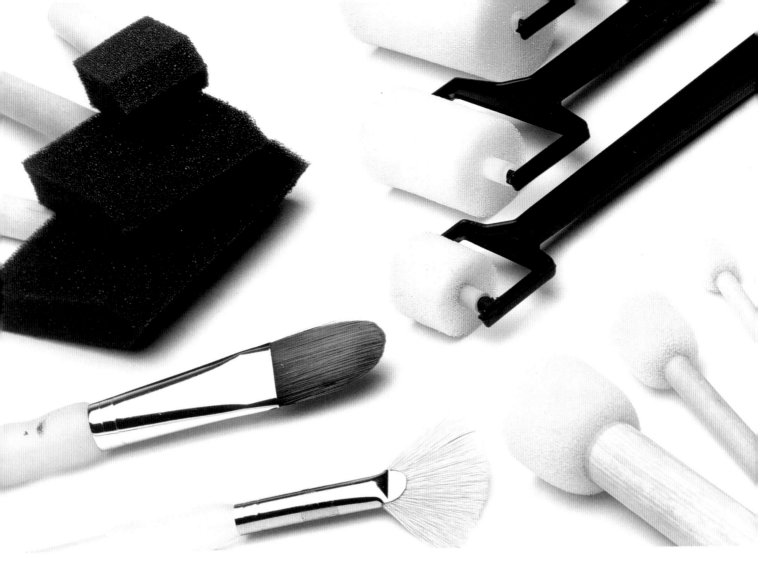

■ Extendible frame. There are many different qualities and types available. Before investing, get to know the different techniques as many direct dyeing techniques do not require a frame. However, some techniques benefit from framing the fabric, particularly when working with fine silks. Select from plastic adjustable frames with metal clasps, plastic clip frames or adjustable wooden frames.

## Equipment for use with thickened dye, discharge paste and resists

■ Toughened glass or thick acetate sheet, such as a laminated sheet.

■ Print roller.

■ Print blocks, stamps, stencils, grouting tools, shaper brushes.

■ Palette knife, available in metal and plastic.

■ Masking tape.

■ Plastic nozzle bottles, available in different capacities and nozzle widths.

■ Freezer paper, useful to make simple temporary iron-on paper masks (available from quilting suppliers).

## Choosing fabrics

Procion MX dyes will dye cotton, viscose, rayon, linen and hemp. They are not suitable for synthetic fabrics such as acetate, polyester and nylon. It is possible to test fabrics for their fibre content. The simplest method is to use the burn test. Cut a small sample of the fabric. Holding it over a basin of water, carefully light one corner. If the fabric is synthetic it melts and forms a hard bead, but care must be taken as some fabrics, such as nylon, melt very quickly.

Try to keep a notebook of fabrics purchased, identifying fibre content, the price and where purchased.

If you find it difficult to purchase fabrics locally, consider buying mail order from one of the suppliers listed at the end of the book. It is often quick and cheap and they will usually be able to repeat the fabric.

There are many reasons, when dyeing, why a certain fabric is selected. It may be that it is for a specific purpose – a quilt, a soft furnishing, a piece of embroidery. It may be selected for its quality – the beautiful, subtle sheen of silk viscose velvet or the bright, crisp transparency of cotton organdie. Whatever the purpose, it is worth devoting some time to investigating and selecting the different fibres and weaves. Obviously there will be some types of material that will not suit your requirements, but try to sample a variety.

Always imagine the selected fabric as viewed through a magnifying glass. Organdie or organza has thin threads, closely woven with fine spaces between them to create the transparent effect. Velvets are plush, like carpets, whereas linens and slub silks can be uneven and include a wide variety of different thread widths and finishes.

It is very important to observe and understand how the different weaves and fibres react and absorb dye. A smooth, fine fabric made of silk satin or spun rayon will absorb dye much quicker than linen or heavy cotton calico. Linen is a much denser fibre, slowly taking in colour, especially when the weave is coarse. It will also appear much darker when wet with dye but as it dries the colours gradually lighten. Cotton organdie is a very fine, transparent fabric that quickly becomes swamped with dye, as it is basically full of holes. Cotton velvet, on the other hand, is a dense, closely woven, piled fabric, greedy for dye. It can be difficult to paint as you are working with or against the pile, but when dry it gives a rich depth of colour. By contrast, silk habotai is a light, lustrous fabric that will give sumptuous colours. It is very closely woven and the threads are shiny and very finely spun. If too much dye is applied rapidly it tends to flood and puddle.

Before purchasing large quantities of fabric, stitch together a range of large swatches suitable for Procion MX dyeing. Using the direct dyeing technique discussed in Chapter 3, paint dye onto the fabrics and observe how the colour reacts.

Consider trying the following: cotton organdie, cotton poplin, cotton calico, cotton velvet, silk noil, silk habotai, silk dupion, silk viscose velvet, viscose satin, spun rayon and linen.

*Opposite page: Selection of natural undyed fabrics.*

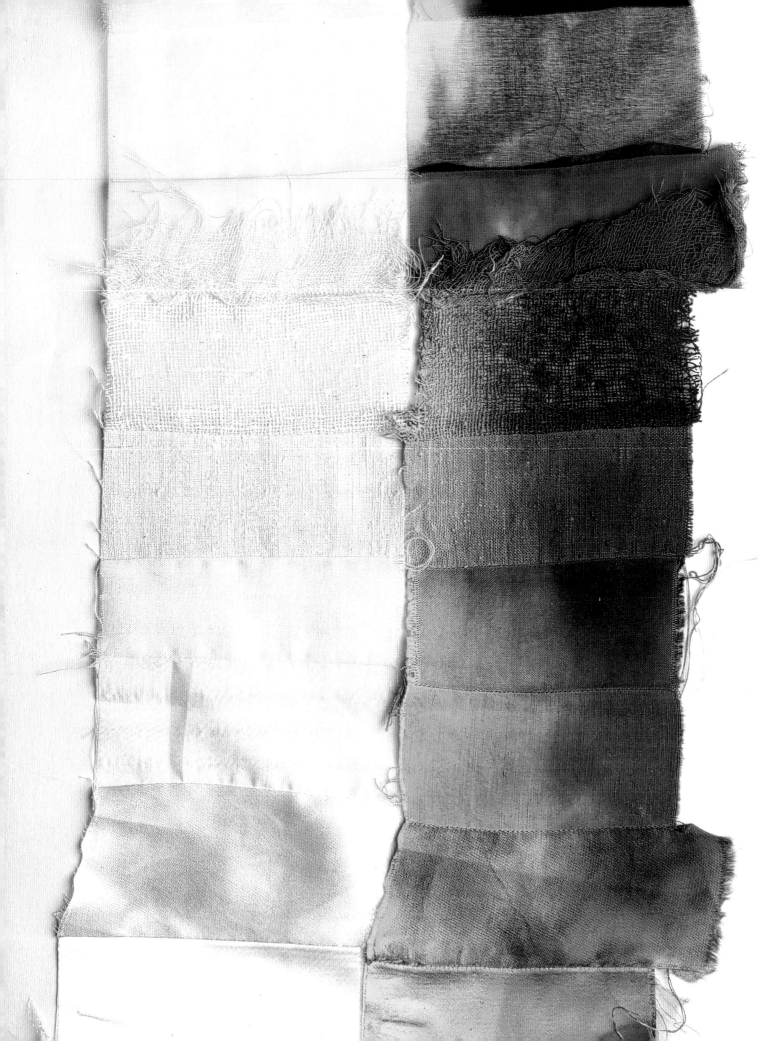

## Preparing fabrics

Having selected the fabrics that you wish to dye, always ensure that they are clean and free from any dressing. Fabrics can be purchased that are already prepared for dyeing. It is easy to test a fabric by painting it with a small amount of water and watching it seep into the surface. If the fabric seems to resist the water, there is probably a dressing in the fabric. To scour the fabric, wash with ½ teaspoon of soda ash and ½ teaspoon of Synthrapol/Metapex 38/Colsperse in hot water for 15 minutes.

When painting directly onto fabric it is useful to have the fabric properly ironed and lying on a flat surface in order to brush the colour onto the surface easily. Some people prefer to stretch their fabric on a frame, but this can bring problems. Large silk painting frames are costly and fiddly to adjust. By selecting a piece of smooth, fairly firm plastic sheeting that can be secured to a surface, fabric can be placed or taped flat on it. Care must be taken when painting very fine fabrics such as silk habotai or organza as the liquid dye will easily flood. As your experience grows, you will learn to control the quantity of liquid in the brush, as well as use different techniques to help dye absorption.

## Health and safety advice

Dyes can produce allergic responses, especially in the respiratory tract. Always heed the following advice.

- Procion MX dyes are chemicals, so should be treated with respect. Washing soda, soda ash and urea are all white powders and can easily be confused.

- Always label and store the above carefully in plastic containers with lids, away from the reach of children.

- Make sure any work area is completely covered with protective plastic sheeting before commencing.

- When mixing dyes or auxiliaries always wear protective clothing, apron, gloves and mask. This is very important when measuring powders and adding hot water to various dyes or chemicals.

- Mix dyes and chemicals in well-ventilated areas.

- Only use equipment that is solely dedicated for that purpose.

- Never eat, drink or smoke when working with dyes or dyeing processes.

- Use soap and water for removing dye splashes from the skin. Do not use bleach to remove dye from the skin as it can give a chemical reaction.

- For stubborn dye stains on the skin use a small quantity of Reduran, a proprietary skin cleaner.

*Opposite page: Strips of different background fabrics, dyed and undyed.*

## Ingredients

Procion MX dyes are fibre-reactive dye powders that are available from a number of suppliers. The following brands are readily available in the UK: Jacquard, Dytek and Kemtex. All Procion MX dyes are identified by a number. Some are 'pure' colours, others are mixed by the manufacturers. Do not become too concerned by the particular names or numbers. It is more important to use your eye and brain and become really familiar with a balanced, limited colour palette. By continually using a particular selection you will learn how to mix them, how to judge different proportions and strengths and thus become skilled at handling dye and colour. Painting or dyeing with dye is not a predictable art. Colour will vary depending on the weave, spin and nature of the fibre as well as the quality of the water used. However, never get despondent, because there is always an adjustment that can be made, by adding more colour, or over-dyeing or even bleaching out.

The 13 colours in the chart below give a really broad colour range to work with. If you feel you cannot afford to invest in such a large number initially, start with the six colours marked with an asterisk.

## Procion MX dye colours

| Dye colour | MX | Jacquard | Dytek | Kemtex |
| --- | --- | --- | --- | --- |
| * Lemon yellow | MX8G | Lemon 004 | Lemon | Acid Yellow |
| * Golden yellow | MXGR | Golden Yellow 010 MX3RA | Golden | Buttercup |
| Tan | MXGRN | Rust Orange 116 | Light Brown | Tan Brown |
| Orange | MX2R | Brilliant Orange 020 | Orange | Brilliant Orange |
| * Scarlet | MX3G | Bright Scarlet 028 MXBA | Scarlet MXG | Scarlet Red |
| * Magenta | MX8B | Fuchsia 040 | Magenta | Bright Magenta |
| Violet | | Violet MXG | Mauve MXR Purple MXB | MX3B Vivid Violet |
| * Blue | | Medium Blue 072 MXR | Ultramarine MX2R | Bright Royal MX2R |
| Cerulean blue | MXG | Cerulean 070 MXG | Vivid Blue MX7RX | Turquoise Blue |
| * Turquoise | MXG | Turquoise 068 | Turquoise | Bright Turquoise |
| Emerald green | MXG | Emerald Green 094 | Emerald Green | Emerald Green |
| Brown | MX5BR | Brown Rose 126 | Dark Brown | Red Brown |
| Black | | Jet Black 150 | Black MXRG | Black |

*Opposite page top: Linen fabric shaded between two colours: lemon and cerulean, emerald green and turquoise, black and magenta, golden yellow and aquamarine.*

*Opposite page bottom: Silk/cotton sateen painted in stripes of adjacent colours.*

Procion MX will dye fibres when dissolved in water and used with salt or urea and soda ash or washing soda. The choice of what to use, when and how, is what makes the different techniques of dyeing so fascinating, complex, irritating and a constant source of discussion and argument.

There are many excellent authors and tutors who have their particular methods for using Procion MX dyes, depending on their requirements and their experience. Dye suppliers also provide excellent advice and recipe sheets. Sometimes trying to sort out all the different techniques and recipes can become

very confusing. The recipes that are used in this book are the ingredients and methods that I have used repeatedly for many years. They suit the way I work and enable me to obtain the fabrics and colours that I need. You must take what you want from these recipes and work with them in your own way.

**Washing soda and soda ash** are dyeing auxiliaries. Washing soda (sodium carbonate) is available from supermarkets. It is a diluted form of soda ash. Soda ash (anhydrous sodium carbonate) is a concentrated form of washing soda and is obtainable from Procion MX dye suppliers.

When either soda ash or washing soda are added to the dye water it becomes alkaline: it is reacting with both the fibre and the water, thus allowing the Procion MX dyes to bond and fix in the fabric. Once the soda solution is added to the dye mixture, the colour will begin to deteriorate because of the reaction that is taking place and will only remain stable for about four hours. Using the dyes after this time will merely stain the fabric, and will not give a fade-resistant or fully washable fabric, so do not mix up more than you need at a time.

The soda solutions above can be used in a variety of different ways depending on the particular dye processes being used.

**Table salt** is used when dip dyeing, or low-immersion dyeing. It helps to drive the dye into the fibres, especially when more water is present.

**Urea** is synthesized from natural gas. It helps the dye to dissolve effectively. It also keeps moisture in the fabric, which in turn helps the dye to bond with the fibres thus giving better absorption of dye colour. It is available from dye suppliers (see page 126).

**Resist Salt L** (Ludigol) is a mild oxidizing agent that helps increase the dye yield, especially in polluted areas such as big cities. It is not essential.

**Calgon** (sodium hexametaphosphate) is a water softener. It helps to neutralize water, particularly in hard-water areas. Sometimes dyes coagulate with hard water, and Calgon also helps when making thickened dye.

**Synthrapol/Metapex 38/Colsperse** is a detergent designed for rinsing Procion MX dyes from fabrics. It can be used for cleansing the fabric before dyeing and is excellent for rinsing.

### Rinsing with Synthrapol/Metapex 38/Colsperse

1. Rinse fabric in cold water until the water appears comparatively clear.
2. Dissolve ½ teaspoon of Synthrapol/Metapex 38/Colsperse in warm to hot water (60°C/140°F) and leave the fabric to soak for 20 minutes.
3. Rinse the fabric in warm water and repeat if the water is not completely clear. Synthrapol/Metapex 38/Colsperse can be used for rinsing in a washing machine, if desired, but do not use more than a teaspoon of solution, as it will produce plenty of foam.

## Disposing of excess Procion MX dyes

Direct painting with Procion MX dyes means that comparatively small quantities are made up. Any leftover dye has become inert by the chemical reactions and can be disposed of normally, along with rinsing water. Excess dye, although exhausted in terms of fabric, can be stored to be used as ink on paper without further deterioration in colour.

# Basic recipes

These are the basic recipes used throughout this book. Different sections will suggest variations or minor adjustments in relation to specific techniques. Please refer to the particular chapters for further details of techniques and methods of using these recipes.

## Solutions for direct dyeing

### Chemical Water
- 140g (5 oz) urea
- 1tsp Calgon
- 1 litre (35fl oz) warm water

Dissolve the ingredients in the water. Label and store in an airtight container.

### Washing Soda Solution
- 200g (7oz) washing soda
- 1 litre (35fl oz) very hot water

Dissolve the washing soda in the water. Label and store in an airtight container.

or

### Soda Ash Solution
- 20g (¾oz) soda ash
- 1 litre (35fl oz) very hot water

Dissolve the soda ash in the water. Label and store in airtight container.

## Thin dye recipe for direct dyeing

For dyeing in a hurry and immediate use.

- ¼–½ teaspoon dye, dissolved in a very small quantity of hot but not boiling water
- 25ml Chemical Water
- 25ml Washing Soda Solution or Soda Ash Solution

Add the Chemical Water to the dissolved dye solution, and then add the soda solution. Apply the dye directly to the fabric (for application methods, see page 42), allow to dry and cure for 4 hours, before rinsing in a solution of Synthrapol/Metapex 38/Colsperse (see page 37).

If the dye colour is too pale, increase the quantity of dye powder used. If too strong, add further Chemical Water and soda solution in equal quantities.

## Dye recipe for pre-soaked fabrics

For fabric that has been pre-soaked in a quantity of Washing Soda Solution or Soda Ash Solution and allowed to dry.

- ¼–½ teaspoon of dye dissolved in a very small quantity of hot but not boiling water.
- 25ml (1fl oz) Chemical Water

Add the Chemical Water to the dissolved dye mixture. Apply the dye directly to the fabric and allow to fully absorb. Apply further dye if required.

Roll the wet pieces up on a polythene sheet. Place in a polythene bag and seal. Leave the dye to absorb for at least 4 hours or preferably overnight.

Remove from the bag and rinse in cold water; then soak in a solution of Synthrapol/Metapex 38/Colsperse (see page 37) to release any loose dye.

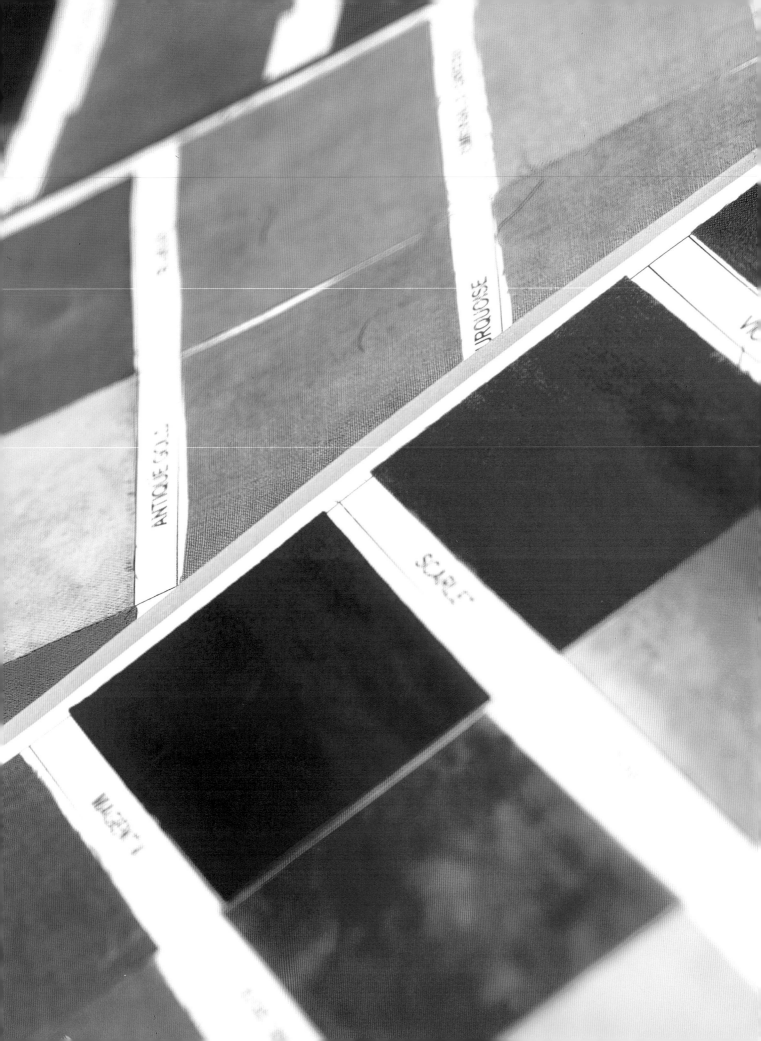

# Chapter Three
## *Direct dyeing methods*

*Direct dyeing or dye painting is an instant and immediate method of applying dye to fabric. It can be as simple as painting on paper or it can become more complex as your experience and confidence grow. The choice is yours and is often dictated by the amount of time you have available.*

# Direct dyeing – painting in a hurry

The beauty of this method is that the results are almost instantaneous. Colours can be placed next to each other, or they can be laid over each other, applied wet on wet or wet on dry. Even when the fabric is dry more colour can be added until the desired effect is achieved.

*Page 40: Pages from a dye chart log, recording the over-dyed colours.*

*Opposite page: Mark-making with dye onto different fabrics such as silk chiffon, silk crystal and silk habotai.*

## Preparation

Select the fabric. A smooth, close-woven fabric is very suitable, such as calico, cotton poplin or viscose satin. A finer fabric – silk habotai for example – is excellent but you may wish to stretch it on a frame. Transparent fabrics, such as cotton organdie, silk organza, and cotton gauze or fine voile can be placed onto absorbent paper, for example watercolour paper, to absorb the excess liquid.

Prepare your fabric by laying it onto a flat sheet of smooth, firm plastic that has been secured to a surface. Secure the edges with masking tape to make sure that it is really flat.

Make sure that you are wearing rubber gloves, an apron and a dust mask before you begin mixing the dyes.

Initially mix up the six basic colours: lemon yellow, golden yellow, scarlet, magenta, medium blue or ultramarine and turquoise. Place each of the dyes in a radial or a deep-welled palette: this gives quick and easy access to the liquid colour. Prepare the dyes to the thin dye recipe for direct dyeing (see page 39) adding both the Chemical Water and soda solution to every colour.

Have a sponge brush or good flat paintbrush, about 2 or 3cm (¾ or 1in) wide for each colour. By having one for each colour, painting is quick and colours remain rich and clear, with less opportunity for dilution or colour contamination.

Have a clean pot of water in case you need to rinse your brush but squeeze out any excess water using a paper towel.

## Method

If it is the first time that you have painted fabric in this way spend time applying the dye. Watch how the dye is absorbed into the different fabrics; observe how some fibres quickly flood whereas others seem to absorb the liquid slowly.

Be aware of how hard you press your brush, whether your brushstrokes are speedy, just touching the surface of the fabric or deliberately heavier, forcing the liquid into the fabric.

Explore the type of marks the brushes make on the selected fabric. Try the same marks on a different weave and fibre.

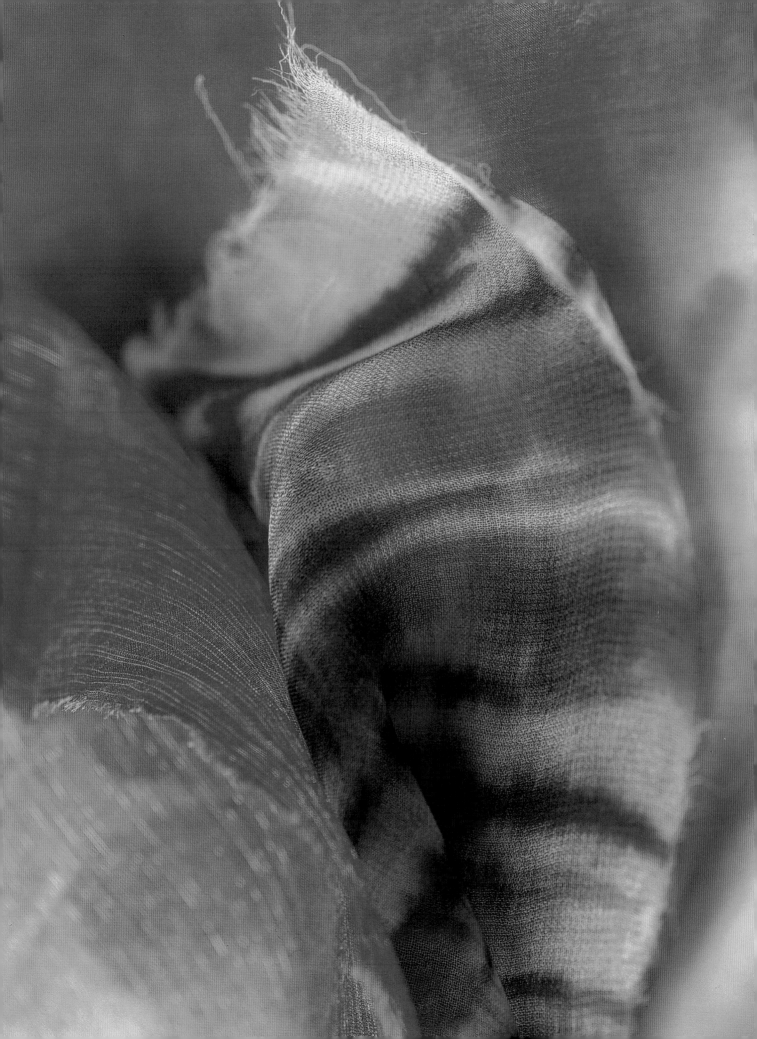

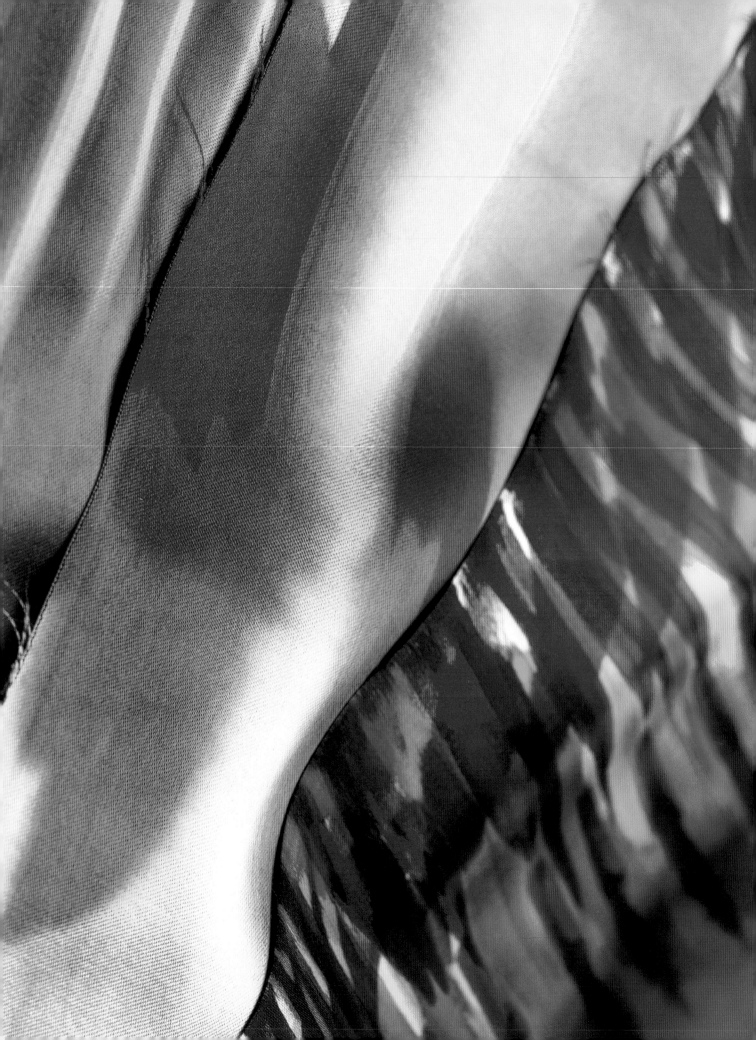

Try a different width and make of brush. Even the quality of the foam sponge will make a difference to the type of mark you obtain.

Become familiar with the colours you have chosen. Try to paint each one in a strip across the fabric, working from light colours to dark colours.

Once dry, try painting the same colours at right angles across each strip, to see what colours you can get when overlaying them.

Paint colours in stripes but leaving a gap between each colour and see how far the dye travels across your fabric. Try using your brush but applying it with different pressure, either by pressing the colour into the fabric or just very lightly stroking the fabric surface.

Observe how your chosen colours react with each other. Be aware that some colours are bullies: they will dominate lighter, more delicate colours.

Remember that all dye colours look darker when they are wet and some will be considerably darker on certain fibres, such as linens.

Remember that colours can be mixed before you paint them, or can be altered by overpainting.

Do not forget colour and pattern ideas can always be explored in a sketchbook as you work, thus building up a wonderful instantaneous reference system.

*Opposite page:* Dye colours painted directly onto viscose satin.

*Following page:* Dye colours painted directly onto calico, sometimes wet on dry and other times wet on wet so that the colour bleeds.

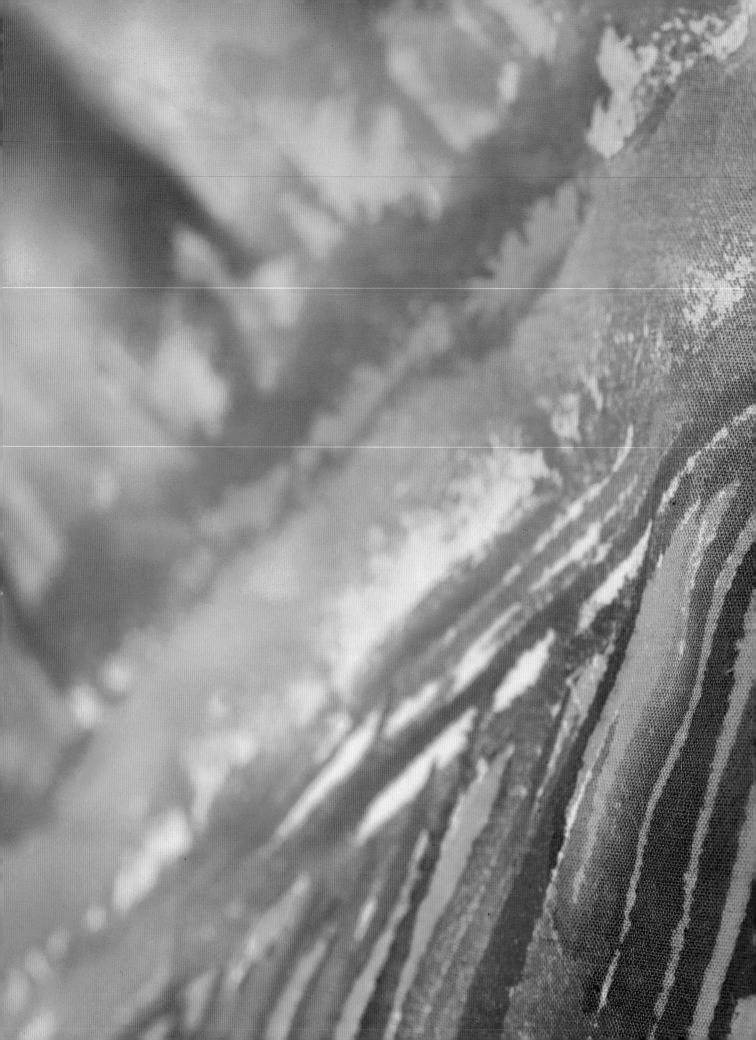

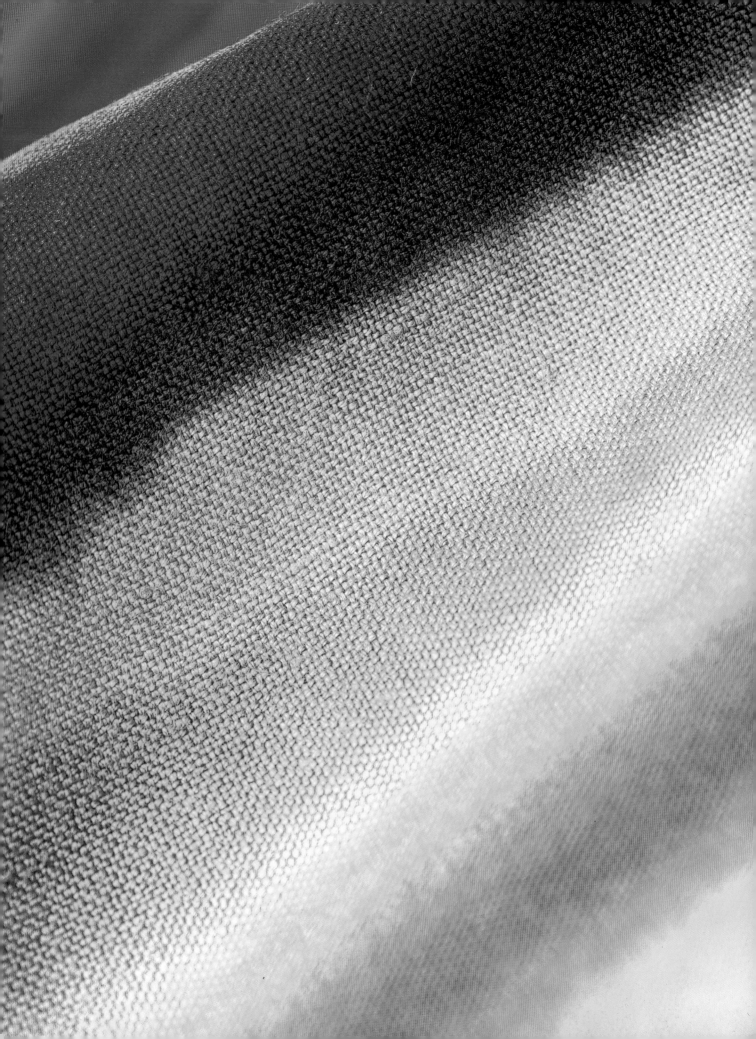

## Types of application

**Sponge brushes** These come in about four different widths up to about 12.5cm (5in). They are very absorbent and so will hold a good quantity of dye. This really helps the application of colour and encourages the design to flow off the brush. Press them firmly and the dye will spread into the fabric; just touch the surface of the fabric and a fine line can be achieved. Sponge brushes can be used for their fine side or their broad side, which also gives a good range of marks. Their flexibility allows them to dance across the fabric, hopping from one area to another in pixelated movements, or dragged in broad, sweeping movements.

**Sponges** Foam sponges, expanding sponges and natural sponges are all excellent applicators. A foam sponge will tend to give an even application of colour, not dissimilar to the sponge brushes. An expanding sponge is available as a very thin, flat sponge. Cut with scissors to your desired shape and placed in water, it immediately expands to three times its size and depth. Natural sponge has a more open structure, giving a random cellular pattern that can create an attractive texture.

*Previous page: Dye colours painted directly onto linen.*

*Below: 'Sponge-brush dancing' on viscose satin.*

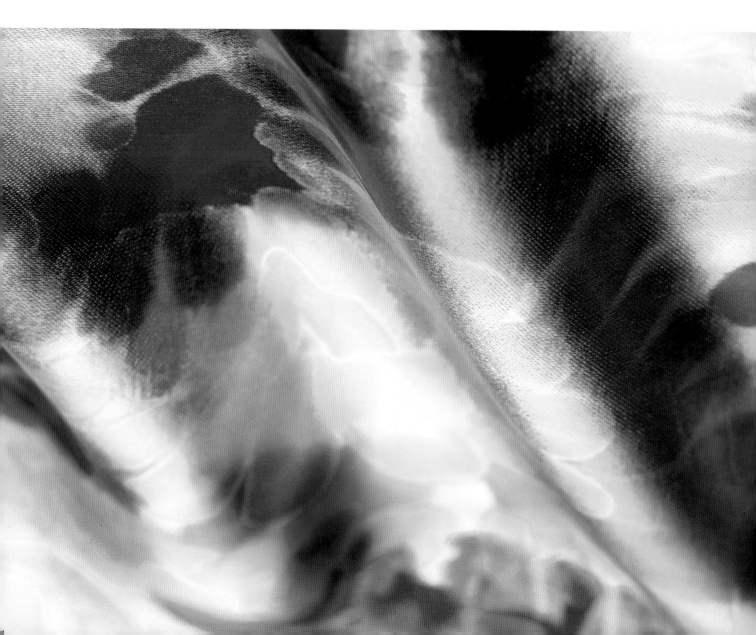

Dip the sponge into the dye and print across the fabric, just gently touching the fabric, taking care not to flood the surface with too much liquid. When using a natural sponge, allow it to absorb the dye so that it is really wet, and then carefully press it onto the fabric, allowing the dye to be transferred from sponge to fabric. With experience, sponges can be brushed and dragged across fabric, giving bold, generous bands of colour.

**Sponge rollers** These are available in ever-increasing widths (and differing qualities). There are fine, narrow rollers with long handles, chunky, patterned rollers (cut with checks, waves and lines) and larger, coarser sponge rollers. Using a roller is a very quick way to get colour onto a fabric. The only disadvantage is the need to have shallow trays full of dye to load the roller effectively.

Use sponge rollers repeatedly to give a background colouring with variety of shades of colour. Use patterned rollers to give a repeated surface, such as squares, ripples and fine stripes.

*Below: Sponge roller with dye used repeatedly on viscose satin.*

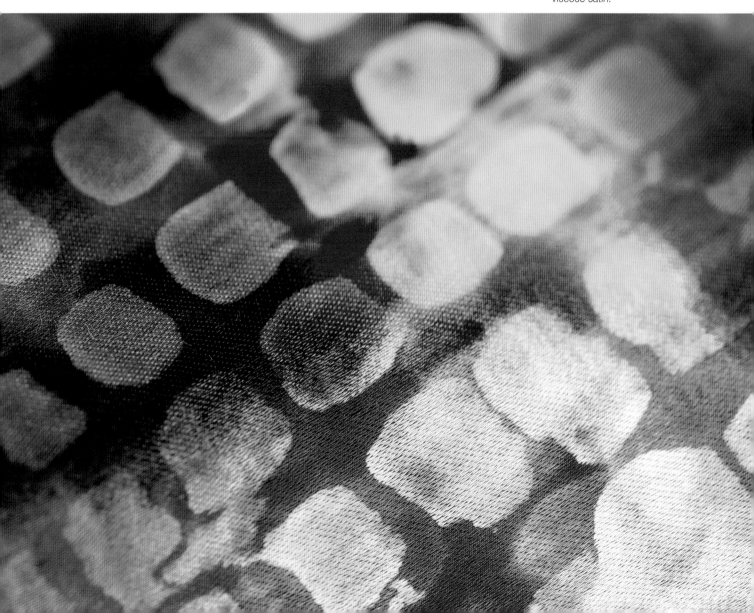

**Brushes** Dye can be applied with a wide range of different brushes from very fine synthetic sable brushes to larger synthetic flat or chisel brushes. Synthetic sable brushes have soft but firm bristles that will hold plenty of dye, and are also easy to draw with on different fabric surfaces. They do not hold as much dye as a sponge brush but will give excellent fine line work and additional definition. It is also worth considering unusual types of brush such as fan brushes that will give a repeated scale-like pattern.

Even an old household bristle brush can give multiple streaky marks that can be used to build up a dyed texture. Coarse bristle brushes can also be used for spattering dye across a fabric.

Brush pens are also available. These are fine felt-tip pens with a small reservoir that can be filled with dye. They are excellent for drawing fine detail onto very smooth fabrics, or for highlighting special patterns and details.

**Pipettes and syringes** These are invaluable for moving dyes from one area of your palette to another as well as measuring quantities of dye. It is also possible to draw with them directly onto the fabric to create a fine line. A little bit of practice is advisable as it is easy to flood the fabric if too much pressure is placed on the pipette bulb.

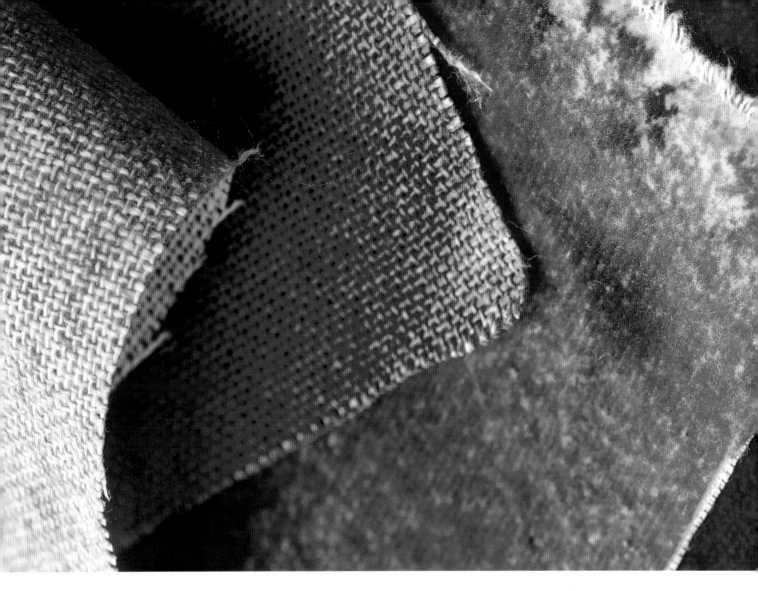

**Sprays/pump sprays** Dye can be decanted into spray bottles and directed onto the fabric surface. If possible, hang the fabric in a vertical position. This gives an even distribution of colour, but if this is not possible, you can still achieve adequate results by laying it out flat. Spray different colours so that the surface of the fabric gradually shades from one colour to another. The result can be extremely rich, layering different colours together to build dense, mottled effects. Care should be taken not to swamp the fabric with dye. Too much and the colour starts to puddle and dribble into unattractive pools.

*Above:* Dye sprayed onto coarse linen and velvet.

## Fabric surfaces

Many attractive and unusual fabrics can be created by working onto a crumpled, creased or ruched surface. Inevitably it is difficult to paint these surfaces but with a little experience, patience and care wonderful random effects can be achieved. Ultimately the actual fibre and the weave of the fabric will dictate the types of marks that you can achieve, but with some experimentation, some analysis of the results and a good deal of sensitivity, lovely fabrics can be created.

# Direct dyeing – with more time

This technique uses the pre-soaked method. In direct dyeing – painting in a hurry (page 42), dye, soda and urea were mixed together and applied directly onto the fabric. The application of the dye in liquid form requires a level of knowledge and sensitivity in order to get the dye to go, and stay, where you want it. It involves knowing how the fibres will absorb the dye and experience of handling the actual equipment. By pre-soaking the fabric in soda solution, letting it dry and then painting it directly with dye and Chemical Water, the quantities of liquid are reduced by half. The dye immediately reacts with the treated fabric, the colour is increased in intensity and the absorption of the liquid can be more easily controlled.

This method does, however, require a bit of forward planning, which is why it is titled Direct dyeing – with more time.

*Right: Detail of dye-painted cotton organdie.*

*Below right: Pre-soaked silk organza, showing the dye halo around the maroon line.*

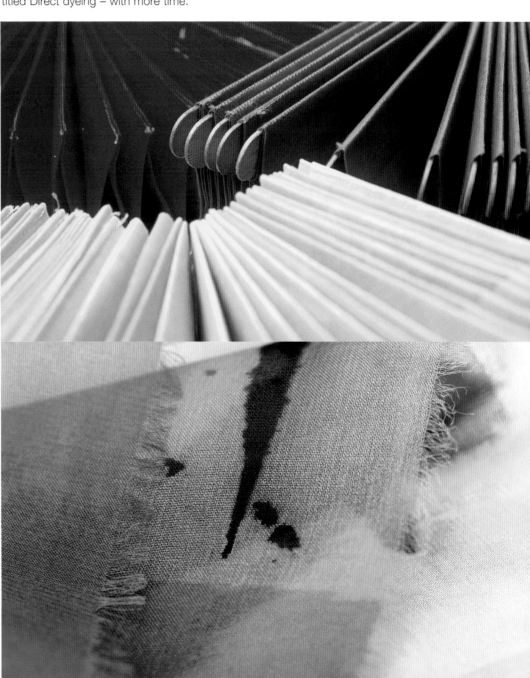

*Left:* *Piece of cotton and linen painted with dye.*

## Preparation

Lay your selected fabric on a flat sheet of smooth, firm plastic and carefully paint or spray the whole fabric with soda solution. It is important to apply the soda solution methodically across the whole fabric area. Leave the fabric to dry flat – this can take some hours, depending on the nature of the fabric and the moisture or humidity of the atmosphere. Alternatively, soak the fabric in a container of solution and, wearing gloves, squeeze out the excess liquid. Hang to dry.

When the fabric is dry, iron with a cool iron, if necessary, making sure the fabric is flat. Then prepare the dye and Chemical Water in the dye palette following the dye recipe for pre-soaked fabric (see page 39). The fabric can be used wet, but the dyed effects will be more liquid in appearance.

Soda solution dries leaving chalky marks – do not allow it to drip onto surfaces.

## Method

Select your equipment, such as sponges, brushes and sprays, outlined above. When first applying the dye carefully watch how it is absorbed into the fabric, notice how the liquid of the dye drives the dry soda through the fibres along the weave. The dye and Chemical Water will move across the fabric until it reaches the extent of the absorption. Often just beyond the dye colour there will be a small halo of dry soda. This can give a very distinct colour line when the fabric is washed. In using this method you are effectively applying wet dye onto dry soda fabric, similar to wet-on-dry watercolour painting.

Every additional application of dye will add further liquid, thus changing the fabric to a wet-on-wet situation. Of course, it is always possible to allow the fabric to dry between applications or to learn how to manage the wet and dry areas of fabric to your advantage.

By pre-soaking the fabric it is possible to restrict the dye easily, as well as produce some unique effects. The colour yield is usually stronger on pre-soaked fabrics.

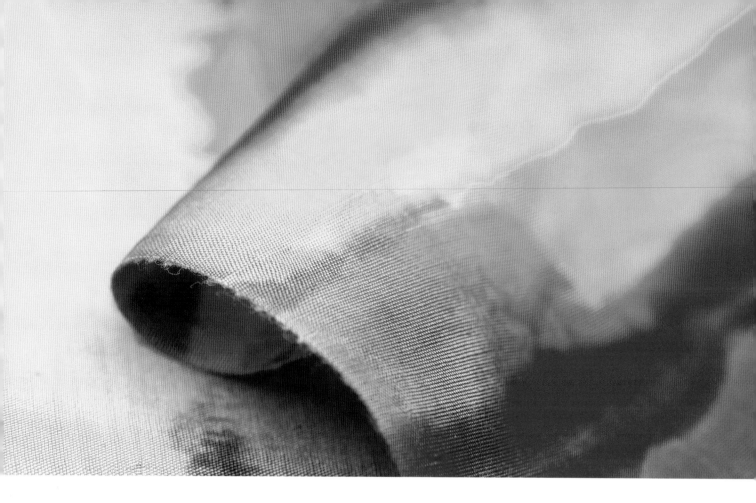

## Recipe for bucket or immersion dyeing

For dyeing in one colour for approximately 2m (6ft) of medium-weight cotton.

- 1 tbsp table salt
- 1–3 tsp dye powder
- 2 tbsp urea
- 1 tbsp soda ash

In a clean bucket dissolve the salt in ½ litre (1 pint) of hot water and allow to cool. The bucket does not need to be an enormous container; it can be a small bowl or tub, depending on the capacity needed for the liquid and fabric. Dissolve the dye powder in a small amount of warm water to create a smooth paste. In a separate container dissolve the urea in ½ litre (1 pint) of warm water and then add the dye paste. Add to the bucket containing the salt solution.

Thoroughly wet the fabric and squeeze out the excess liquid. Immerse the fabric in the dye bath, ensuring that there is sufficient liquid to cover all the fabric. Stir the fabric continuously for 15 minutes.

Dissolve the soda ash in ½ litre (1 pint) of hot water and leave to cool. Add to the dye bath and stir. Allow the fabric to soak for a further hour, stirring regularly to prevent uneven and patchy dyeing.

*Above: Silk and cotton that has been presoaked with soda solution, showing how the dye colour creates subtle colour halos.*

Remove the fabric from the dye bath and rinse in cold water. Soak in a solution of Synthrapol/Metapex 38/Colsperse (see page 37) for 20 minutes. Rinse again until the water is clear.

Procion MX dyes provide an excellent colour range for dyeing larger pieces of fabric. Fabrics that have been painted, printed or space-dyed can be over-dyed by immersion dyeing to subdue the colours or unite a dyed effect.

It is important, however, to know how the colours will change when they are over-dyed. Certain colours will still dominate even when over-dyed, such as magenta and lemon yellow. It may be advisable to reduce the amount of dye powder when making up these immersion-dye colours so that they do not obliterate the original colours.

Remember that for evenly dyed fabrics there must be ample room for the fabric to be moved, regularly agitated, rearranged and stirred. However, if mottled, uneven dyeing is required, place the fabric in a cramped container, hardly move it and you will get shaded, mottled results that are attractive in their own right.

*Below:* Silk and cotton presoaked and dyed with violet and lemon yellow, showing the interaction of colours.

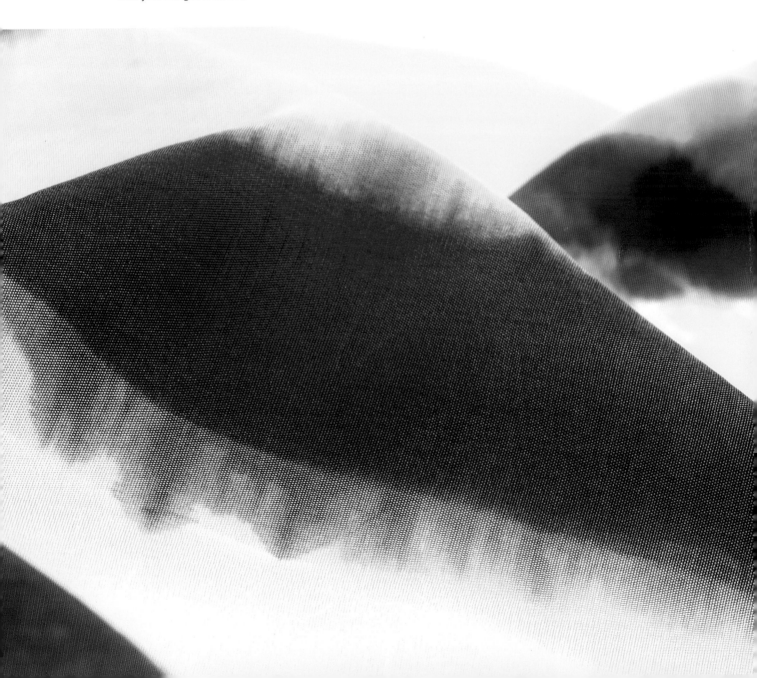

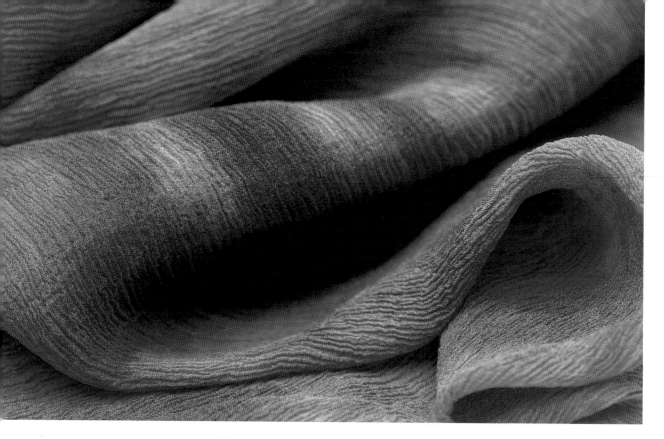

*Above: Space-dyed mousseline over-dyed in ultramarine.*

# Dyeing methods for lengths of fabric

## Layered dyeing

For use when you want to achieve a subtle, textured colour.

Choose a small bucket in which the fabric will be tightly contained and crumpled. Select three pieces of heavy-weight fabric such as calico, linen or viscose satin, about 45cm (18in) square.

Mix up three contrasting Procion MX colours to the thin dye recipe for direct dyeing (see page 39), such as scarlet, marine violet and emerald green, but do not add the soda solution yet. Dampen the fabrics and squeeze out any excess liquid.

Press one piece of fabric into the base of the small container, making sure it is really crumpled. Pour on one dye, scarlet, across this fabric and press down but do not move it. Allow the dye to absorb into the fabric, then add the second piece.

Repeat the process for the second piece of fabric with the second colour, marine violet. When you press the fabric down some of the first colour will seep up. Allow the dye to absorb again and then add the third piece of fabric.

Repeat the process with the third colour, emerald green, and press down, allowing the marine violet to seep up. Allow the fabric to absorb the dye as before. After 10 minutes, pour 100ml (3½fl oz) of soda solution over the fabrics and press down but do not agitate the fabrics.

*Opposite page: Layered dyeing using viscose satin and scarlet/marine violet and emerald green dye.*

Leave for at least an hour undisturbed, or preferably overnight. Remove the fabrics from the bucket and rinse firstly in cold water, then soak for 20 minutes in a solution of Synthrapol/Metapex38/Colsperse (see page 37) to release any loose dye. Repeat until the water runs clear.

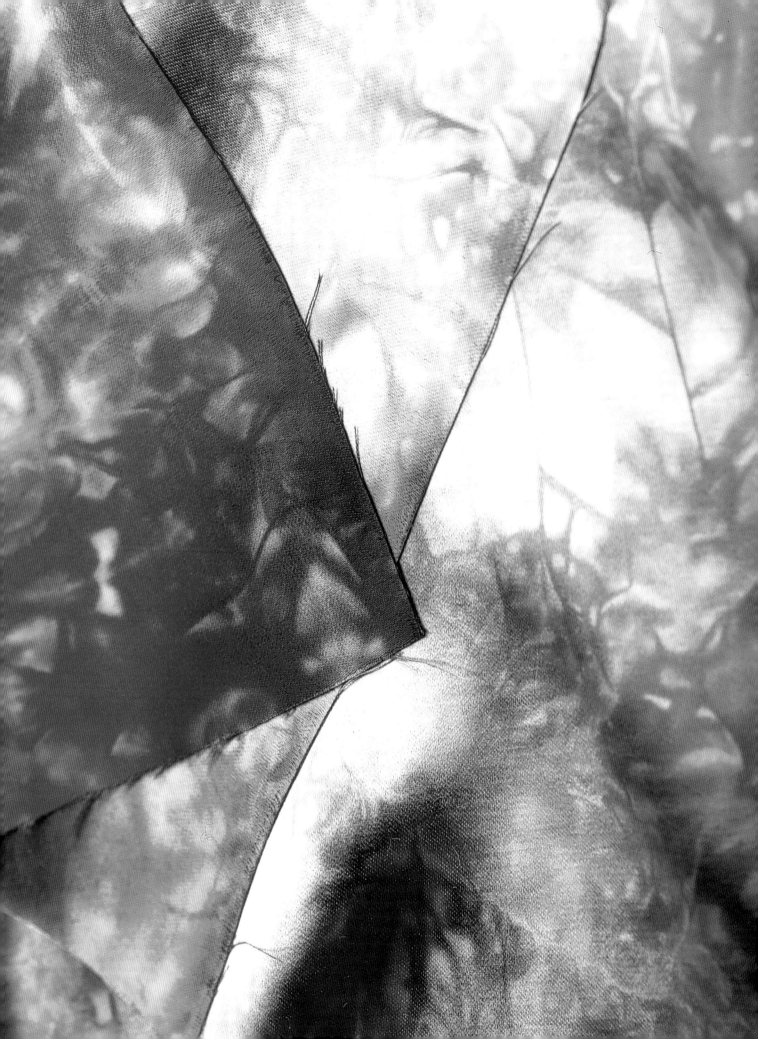

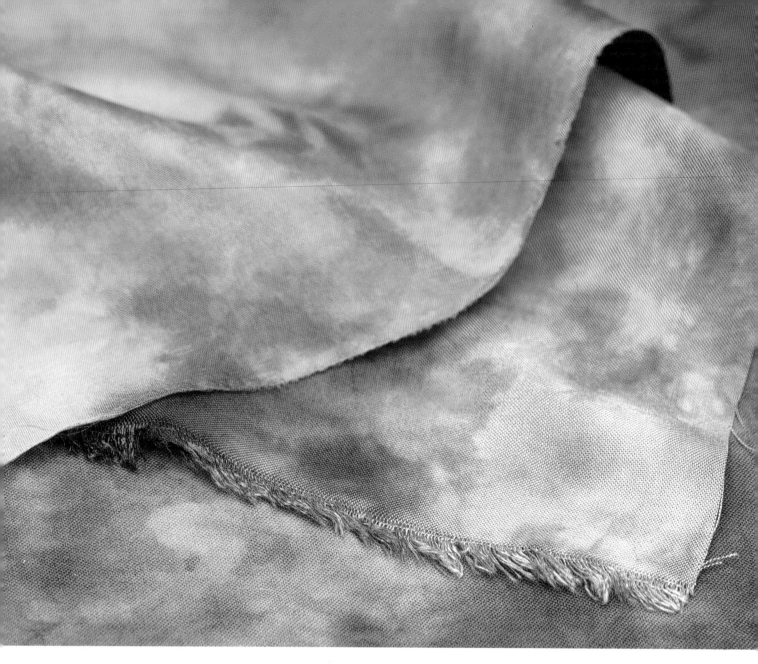

## Alternative layered dyeing

Rich, multicoloured fabrics can be dyed together in a bucket using the same method as layered dyeing, but this time adding three dye colours for each layer of fabric.

Select four pieces of fabric of different weights and fibres such as calico, linen, silk habotai and spun rayon, about 45cm (18in) square.

Mix up three contrasting Procion MX colours to the thin dye recipe for direct dyeing (see page 39), such as turquoise, golden yellow and brown rose, but do not add the soda solution yet. Dampen the fabrics and squeeze out the excess liquid.

Selecting a suitably small container, tightly crumple the first fabric and place in the bottom. Dot on one dye, golden yellow, across this fabric, leaving spaces for the second dye, turquoise, and third dye, rose brown. When all three dyes have been added, lightly press down but do not move the fabric. Allow the dye to absorb into the cloth and then add the second piece. Repeat the process, adding all

three colours. Allow the dye to absorb and then add the third piece of fabric and repeat the dyeing process.

Finally, add the fourth fabric, apply the dyes, press the fabric down and allow it to absorb the dye. After 10 minutes pour 100ml (3½fl oz) of soda solution over the fabrics and gently press down but do not move the fabrics.

Leave for at least an hour undisturbed, or preferably overnight. Remove the fabrics from the bucket and rinse firstly in cold water, then soak in a solution of Synthrapol/Metapex38/Colsperse (see page 37) for 20 minutes to release any loose dye. Repeat until the water runs clear.

## Crumpled dyeing

This is a simple method to create a multicoloured, random, textural dyed effect.

Crumple and place a damp 1m (39in) square of fabric into a large, shallow tray, making sure the surface of the fabric has plenty of creases and tucks. Mix up three or four Procion MX dyes, to the thin dye recipe (page 39), but do not add the soda solution yet. Carefully drip the different dye colours across the fabric, spacing them and occasionally pressing the dye into the fabric so that the colours can run and mix into each other. Leave for 10 minutes.

Pour 100ml (3½fl oz) of soda solution across the fabric. Leave in the tray for at least an hour without moving the fabric, or preferably overnight. Remove from the tray and rinse firstly in cold water, then soak in a solution of Synthrapol/Metapex 38/Colsperse (see page 37) for 20 minutes to release any loose dye. Repeat until the water runs clear.

Note that the less the fabric is moved, the more defined and sharp the dyeing patterns will be. Choose the dye colours carefully, remembering that the dyes will mix and give secondary and tertiary colours.

*Below:* Crumpled dyeing using cotton lawn and violet, brown rose, turquoise and golden yellow.

## Painting a length of fabric

It is possible to hand-paint a larger length of fabric using the thin dye recipe. If the fabric is light-weight, such as fine cotton lawn, cotton organdie or silk habotai, it is quite quick to paint 2–3m (2–3 yards), and does not require a large quantity of dye. However, heavier fabrics such as calico, cotton velvet and linen require considerably more dye and can be very laborious to paint.

Secure a large sheet of medium-weight polythene onto a flat surface, such as a table, the floor or somewhere outside, out of the sun. Lay the fabric flat onto the polythene and attach with masking tape at intervals.

Using the thin dye recipe, mix a generous quantity of dye, about 100ml (3½fl oz). The quantity will depend on the absorbency of the fabric, but if you carefully measure the ingredients, it is possible to make up additional dye. Apply the dye with a wide sponge brush and work quickly, so that all the fabric is wet.

For a good, strong retention of colour, roll up the polythene sheet with the fabric still attached and place in a sealed plastic bag overnight.

Using a large tub, basin or bucket, rinse the fabric and polythene in cold water. Remove the fabric and soak for 20 minutes in a solution of Synthrapol/Metapex 38/ Colsperse (see page 37). Rinse again until the water is clear. Spin to remove excess water and hang to dry.

This method is very useful if shaded or graduated coloured fabrics are required.

*Opposite page:* Detail of Mechanistix, *from* Material Works: Off the Wall *exhibition by the Practical Study Group at Enginuity, the Museum of Iron, Ironbridge, Shropshire, UK. Large-scale dyed and folded organdie piece, hand-painted in 7-metre (23-foot) lengths.*

# Dye process reference chart

| Technique | 1. Preparation | 2. Dye+ what | 3. Post-dyeing | 4. Fixing |
|---|---|---|---|---|
| Direct dyeing – painting in a hurry | No pre-soak, keep fabric dry | Dye + Chemical Water + soda solution | Dry then rinse | Fixing done in 2 |
| Direct dyeing – with more time | Pre-soak with soda solution. Dry | Dye + Chemical Water | Dry then rinse, or wrap in plastic, store overnight in bag; rinse | Fixing done in 2 |
| Immersion/bucket dye | Damp fabric | Dye, urea/salt in container | Add soda solution after 15 minutes | Remove after 1 hour, rinse |
| Space dyeing | Damp fabrics and threads | Dye + Chemical Water | Add soda solution | Leave 45 mins, then rinse |
| Pattern dyeing | Soak in soda solution. Dry | Dye + Chemical Water | Seal in bag overnight | Rinse, dry, untie |
| Dyeing in polythene bag | Damp fabrics | Dye + Chemical Water | Add soda solution | Leave in bag for 4 hours |
| Dyeing families of colour | Damp fabrics | Dye + Chemical Water | Add soda solution | Leave in bag for 4 hours |
| Wax, direct painting | Dry fabric | Dye + soda solution + Chemical Water | | Dry, then rinse and dry before next waxing |
| Wax, immersion dyeing | Wet fabric | Immersion dye, urea/salt in container | Add soda solution to dye bath after 15 minutes | After 1 hour, rinse/dry before next waxing |
| Flour paste | Pre-soak in soda solution and dry | Dye + Chemical Water or thickened dye | Heat fix in oven 150°C/300°F/gas mark 2 for 5 minutes | Dampen and remove paste |
| Potato dextrin | Pre-soak in soda solution and dry | Dye + Chemical Water or thickened dye | Heat fix in oven 150°C/300°F/gas mark 2 for 5 minutes | Dampen and remove paste |
| Thickened dye Method 1 | Pre-soak in soda solution and dry | Thickened dye | Heat fix in oven 150°C/300°F/gas mark 2 for 5 minutes or iron fix | Wash |
| Thickened dye Method 2 | | Thickened dye plus sodium bicarbonate | Heat fix in oven 150°C/300°F/gas mark 2 for 5 minutes or iron fix | Wash |
| Discharge, without colour added | Direct dye | Wash and dry | Discharge paste, dry | Discharge with steam iron & wash |
| Discharge, with colour added | Direct dye | Wash and dry | Discharge paste with fabric paint added | Discharge with steam iron & wash |
| Bleach | Apply bleach to fabric | Rinse in water | Neutralize in vinegar | Rinse again |

*Opposite page: Enlargement of hand-painted silk organdie.*

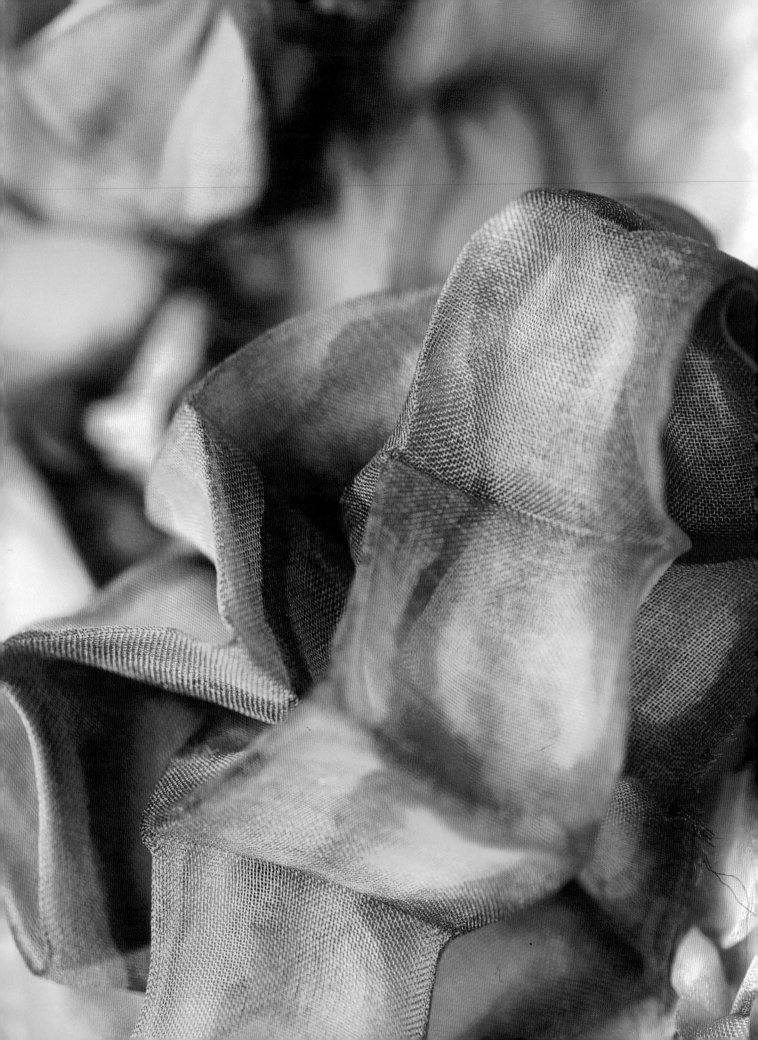

# Chapter Four
## *Advanced techniques*

*For those with more experience and a little more time to devote to their dyeing projects, this section offers additional methods for dyeing quantities of fabrics, either the same colour or different colours simultaneously, plus advanced dyeing techniques using layering, folding and rolling.*

*Page 64: Detail of folded and dyed silk organza.*

*Opposite page: Range of dyed fabrics from lemon yellow through blues to violets and magenta, reds and finally oranges and golden yellows.*

# Dyeing small quantities of fabric in a polythene bag

This is an efficient way to dye small pieces of fabric in numerous colours. By mixing dyes in strong solutions and using polythene bags rather than buckets and bowls, the whole operation can be carried out on a table covered with polythene or newspaper and not necessarily near a sink.

For students who like to get together for a dyeing session it is an ideal method, as all the dyed fabrics go home in polythene bags to be rinsed later. You can mix your colours really quite accurately by trying the colours on paper before actually immersing your precious fabrics in the dye.

The following methods are not particularly quick for dyeing as the preparation of the fabrics, the making up of the dyes and then the actual dyeing, rinsing, ironing and documenting can take some time. However, in the end you not only have a wonderful collection of fabrics to use but your knowledge of colour and colour mixing is greatly enhanced.

## Fabrics

The following recipe is suitable for about five pieces of fabric 14 x 30cm (5½ x 12in) per bag. Select fabrics of natural fibre (cotton, silk, viscose, rayon, linen or mixed fibres) and try to include different weaves and weights. The following fabrics give good results.

- Silk: habotai, chiffon, mousseline, georgette, noil and dupion.

- Cotton: cheesecloth, muslin, voile, scrim and poplin.

- Viscose/rayon: satin, spun rayon, silk and viscose satin.

- Linen: even weave, slub and linen and cotton unions.

- Mixed fibres: part synthetic and part natural where the synthetic will not dye, leaving a white pattern.

Stick a small piece of each piece of fabric that you use in your sketchbook or a notebook and label it. As you dye the fabrics, observe how weaves and fibres absorb colours differently and try to document that as well.

## Recipe for dyeing fabrics in a polythene bag

The quantity of dye prepared in this recipe should be sufficient for at least 12 different coloured bags of fabrics, depending on the number and types of fabrics chosen.

Prepare a Chemical Water solution and either Washing Soda Solution or Soda Ash Solution in the quantities given on page 68 and then prepare the dyes.

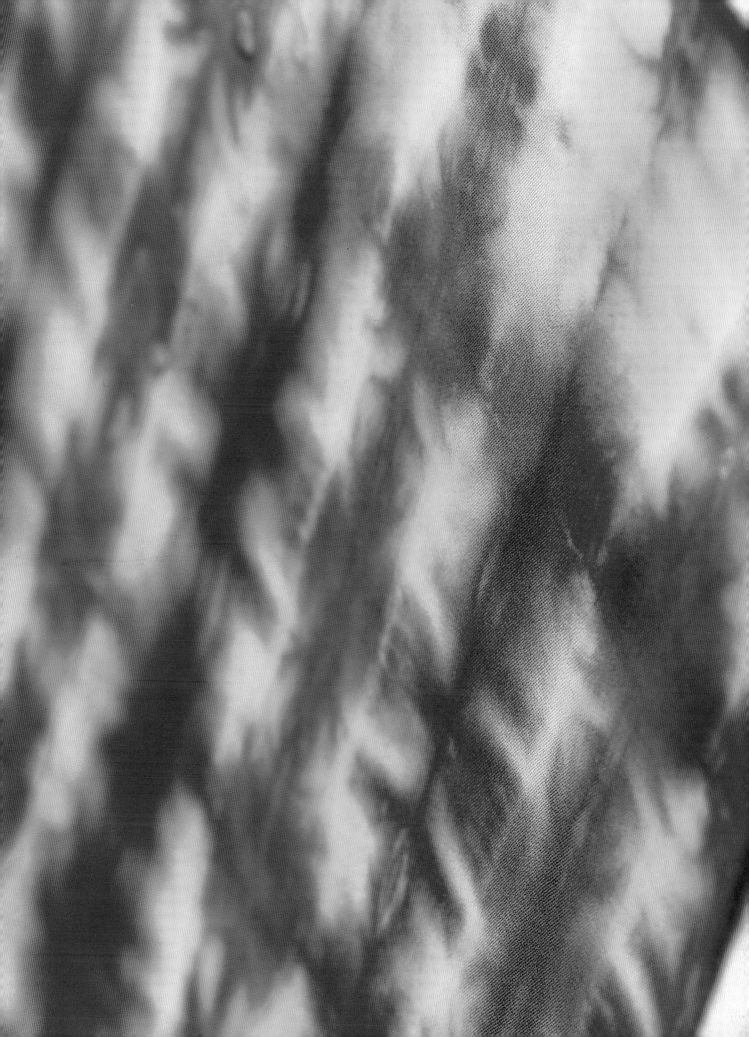

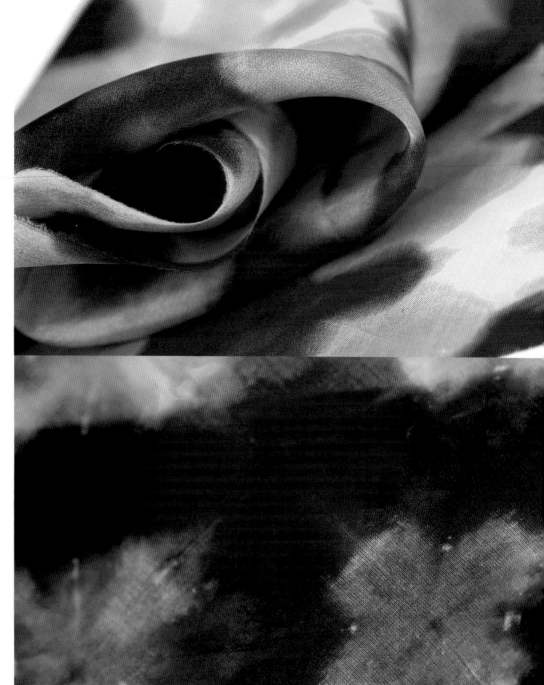

*Previous page: Cotton poplin folded into squares, soaked in soda and dyed wet.*

*Above right: Silk habotai folded diagonally and dyed in magenta, golden yellow and ultramarine.*

*Right: Cotton organdie folded diagonally.*

**Diagonal folding** This gives diamond and diagonal patterns. Cut a 25cm (10in) square of fine fabric that has been pre-soaked in Washing Soda Solution or Soda Ash Solution. Iron it flat. Fold the corners into the centre of the square. Repeat this process as many times as the fabric will allow. Fold the fabric into a triangle and bind with fine thread repeatedly across the sides so that the corners are exposed. Apply dye by dipping the corners into a shallow dye bath or by painting the dye onto the parcel.

**Rolling** These will give gradually altering patterns. Cut a long, narrow strip, approximately 25cm (10in) wide and 50cm (20in) long, of fabric that has been pre-soaked in Washing Soda Solution or Soda Ash Solution. Iron it flat. If possible, find a thin stick such as a kebab stick and, starting from one narrow edge, roll the fabric tightly around it.

Holding the thread in one hand, tightly bind the roll, continually pulling it as you wind the thread around the parcel. Patterns can be created by the way the thread is wrapped: stripes by wrapping in bands; diamonds by binding diagonally down the roll and back up to create a mesh pattern. Apply the dye by gently painting all exposed fabric surfaces. Remember that the thread is forming the resist and therefore the pattern. It should be preventing the dye from colouring the fabric beneath it. Also remember the centre of the roll will get less dye. Place the roll in a polythene bag and seal.

**Rolling around a rope** By wrapping the fabric around a thick twisted rope, cord or grooved plastic tube it is possible to use the ridges to give guidance for regular pattern lines. Apply dye by painting it onto all the exposed areas of fabric. Dye as before, place in a polythene bag and seal.

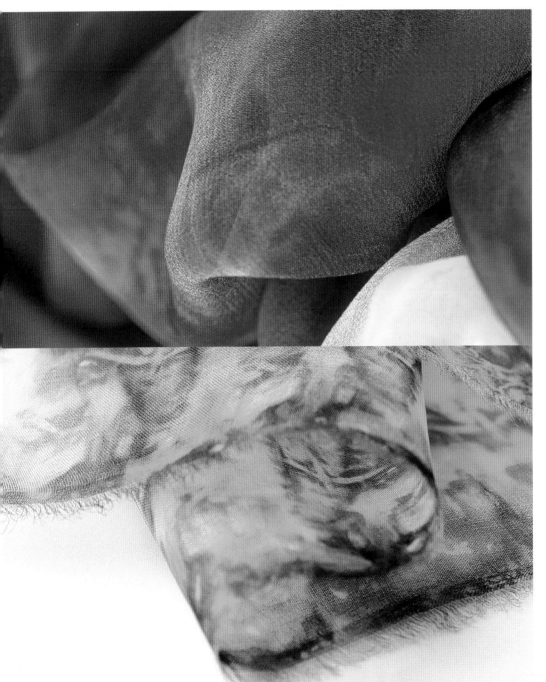

*Left:* Silk chiffon and georgette pieces rolled around a rope, tied and dyed.

*Below left:* Rolled organza in orange and greens.

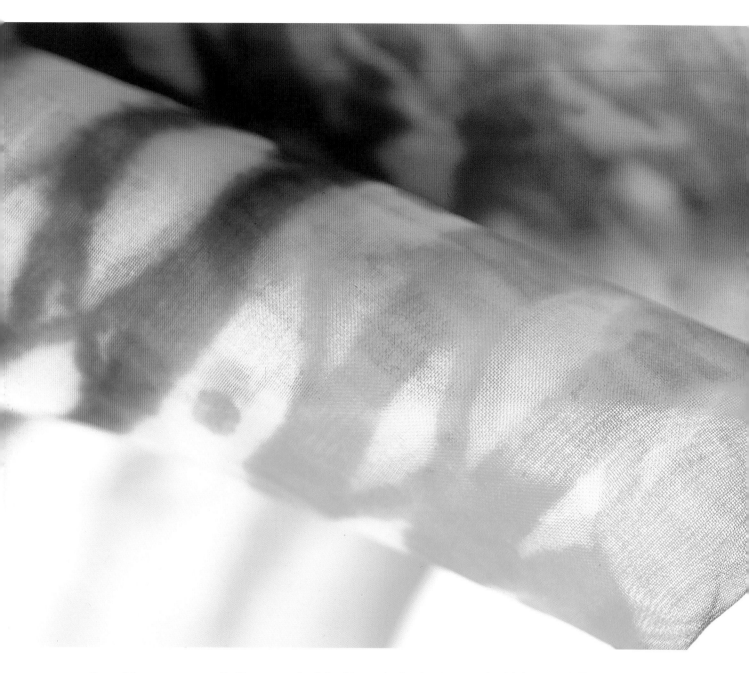

*Above: Silk organza rolled and tied around a ridged tube, leaving very distinctive patterning.*

**Rolling around a tube** Use a plastic pipe to wrap the fabric around. Evenly bind the fabric tightly to the tube, leaving a gap between each row of thread. Hold the tube firmly at one end and force the fabric up the tube so that it ruches together. This will make the fabric pleat, giving fine patterning. Apply the dye slowly to the outer surface using a sponge brush so that the dye can penetrate the inner layers. Place in a polythene bag and seal.

**Folding and rolling** It is possible to fold and roll larger pieces of fabric, such as a 90cm (36in) square, especially fine fabrics – chiffon or georgette, for example. The patterns will repeat, forming mirror images and giving symmetry to the whole piece. Lay the fabric square flat and fold the outer edges into the centre, making a piece 45 x 90cm (18 x 36in). Fold the shorter edges into the centre, creating another square. Fold the square into a triangle and roll the fabric around a stick from the longest edge to the point of the triangle. Bind the roll, dye and place in a polythene bag as before. This will give an unusual pattern, combining folding and rolling.

*Above: Silk organza, initially folded then rolled around a kebab stick, tied tightly and injected with dye.*

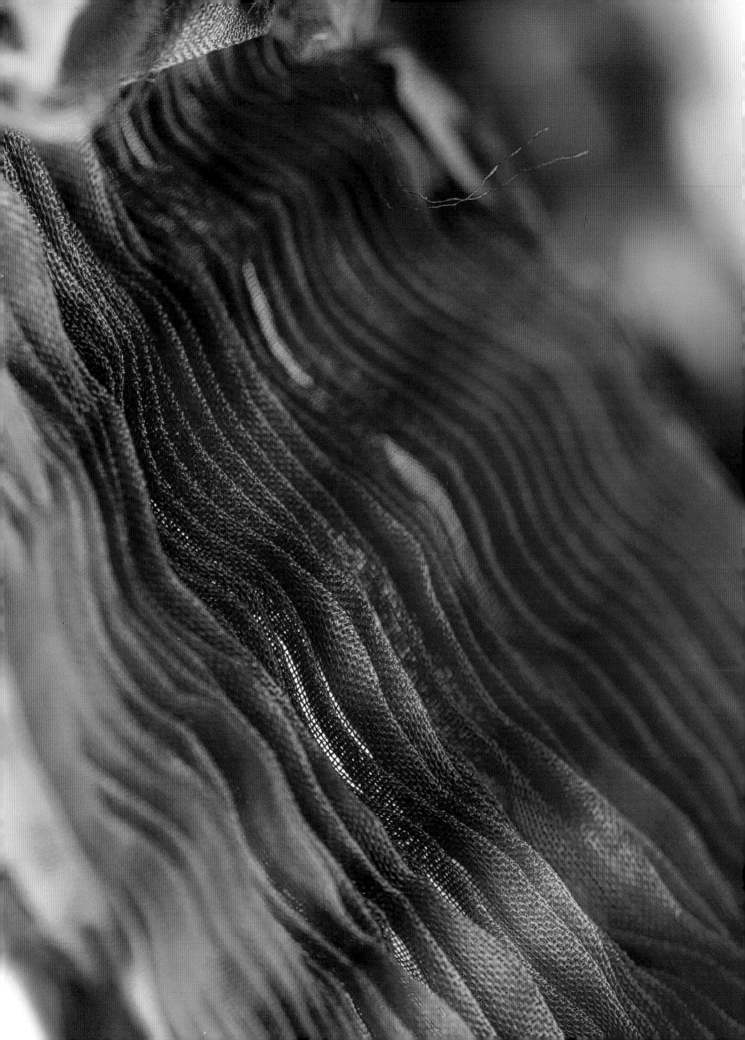

**Smock gathering** If you are lucky enough to have access to a smock-gathering machine, use that to gather some very fine fabric tightly. Once gathered through the machine, pull the threads up very firmly and fasten off. Either soak the fabric in soda solution before you gather it or once gathered. Lay the fabric onto a piece of polythene and carefully brush the gathered surfaces with thin dye. When the fabric is dry check that the dye has penetrated as far as you would like. Rinse the fabric while still tightly tied and allow to dry. When fully dry untie. If you wish to keep the pleats, briefly steam the fabric for five minutes in a steamer.

## Finishing and rinsing

For all the projects above, leave the parcels tied and wrapped for the length of time recommended. Then rinse thoroughly in cold water, before soaking for 20 minutes in a solution of Synthrapol/Metapex 38/Colsperse. Rinse until the water is clear and dry before unwrapping.

Careful unwrapping can reveal beautiful patterns. Some fabrics will be ruched and puckered by the tight binding. These fabrics can be very attractive without pressing and will keep their form for many years.

*Opposite page: Smock-gathered and pleated fabric dyed in golden yellow and black.*

*Below: Silk organza and silk habotai rolled together, tied and dyed.*

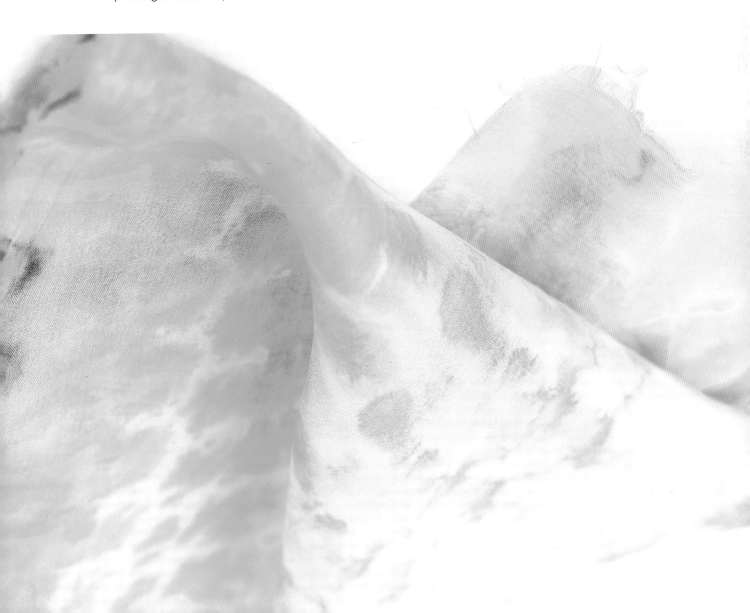

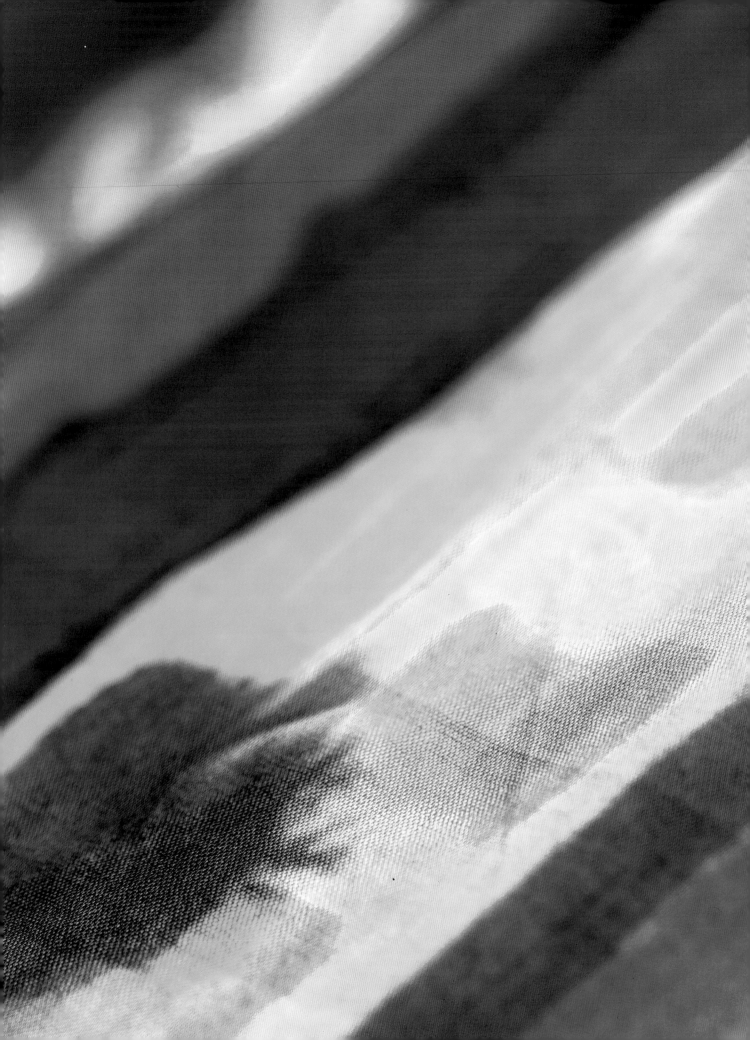

# Chapter Five
## *Dye thickener*

*The range and versatility of Procion MX dyes have already been discussed. The added bonus is that they can be thickened and used as a rich, transparent printing and painting colour, which usually gives a noticeably stronger colour after washing and fixing.*

*Page 86:* Lines of thickened
and unthickened dye
on cotton lawn.

*Opposite page:* Viscose satin,
with squares of thickened and
thin dye used as colour and
mark-making experiments.

Mix Procion MX dye with a Manutex (sodium alginate) paste and a transparent dye paste can be created that can be used for printing, stencilling, screen-printing and painted applications. There are two Manutex (sodium alginate) thickeners currently available.

**Manutex F700 (Jacquard Sodium Alginate F)** has a high solid content, is used for overprinting, and gives excellent fine line definition on fine fabrics.

**Manutex RS (Jacquard Sodium Alginate SH)** has a low solid content, is used when there are no overprints and can be used on thicker fabrics. This type is more widely available, because it is regarded as more versatile.

Note that the two types of Manutex (sodium alginate) powder require different quantities.

## Recipe for thickened dye

- 100g (3½ oz/10 tbsp) urea
- 1 tsp Calgon
- 375ml (½ pint) hot water
- 4 tsp Manutex RS (Jacquard Sodium Alginate SH) or 9 tsp Manutex F700 (Jacquard Sodium Alginate F)
- 575ml (1 pint) cool water

Mix the urea and Calgon with the hot water in a plastic bowl until dissolved. Slowly add the Manutex (sodium alginate) powder by sprinkling and stirring. If possible use an electric mixer, which helps give a lump-free consistency. Finally, slowly pour in the cool water and mix thoroughly.

This will make 900ml (1½ pints) of thickener.

There are two methods of activating the thickened dye to react into the fabric. Either apply Washing Soda Solution or Soda Ash Solution (see page 38 for recipes) to the fabric prior to application or add sodium bicarbonate in powder form directly into the thickened dye colour at the time of printing. Both methods work extremely well and need to be heat fixed.

## Pre-soaked fabric

Pre-soak the fabric with soda solution and allow to dry.

(If pre-soaking viscose rayon, substitute soda solution with 25g (1oz) of sodium bicarbonate to 1 litre (2 pints) of water.)

Mix 2 teaspoons of Procion MX dye powder (the quantity of dye powder is dependent on the strength of the colour required) with 125ml (¼ pint) of dye thickener. This paste can be stored in cool conditions for up to a week.

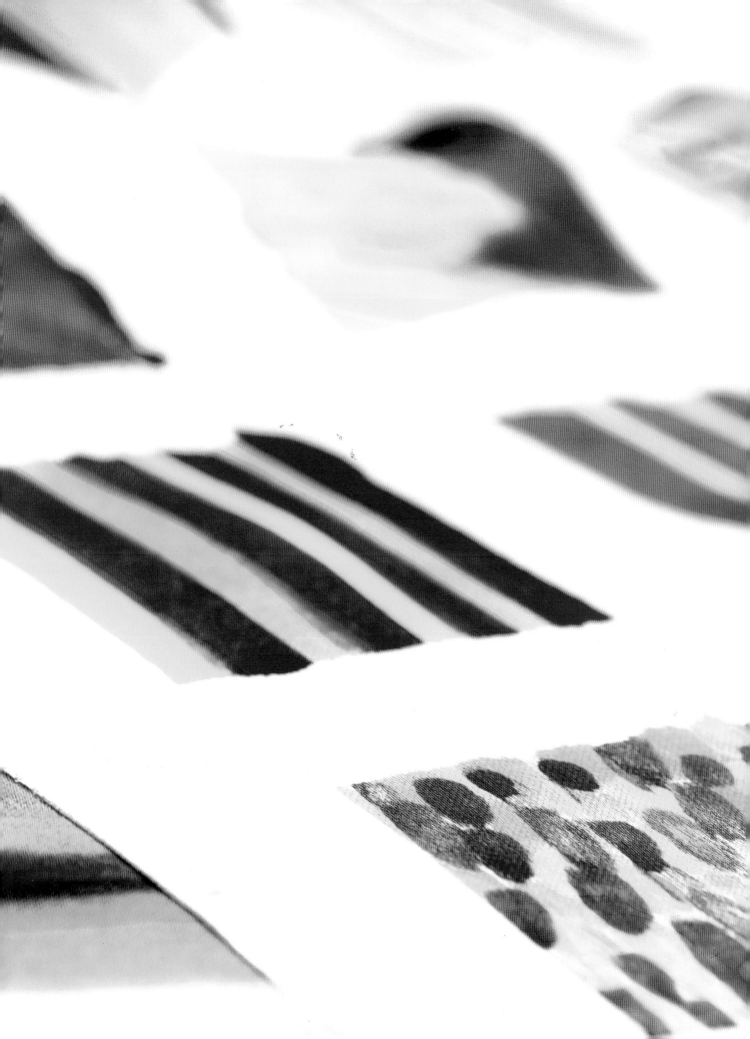

*Right:* Thickened dye painted and sponge-printed onto linen, with a second application of thickened dye, then finally an application of thin dye.

## Fabric not pre-treated with soda solution

Mix ½ –2 teaspoons of Procion MX dye powder (the quantity of dye powder is dependent on the strength of the colour required) with ½ teaspoon of bicarbonate of soda and 125ml (¼ pint) of dye thickener. This paste only remains usable for four hours.

## Application of thickened dye

Thickened dye can be applied in a number of ways, such as those described later in the chapter, as well as combined with resist methods such as flour paste and potato dextrin (see pages 104 and 109). It can be also be used with direct dyeing and even used as a partial resist. Mix the thickened dye colours and apply to the fabric by the chosen method. Leave to dry.

## Fixing thickened dye

Either bake the fabric in the oven for 5 minutes at 150°C/300°F/gas mark 2 to fix or iron for 5 minutes at a heat setting suitable for the fabric, making sure all areas are fully heat treated.

## Rinsing and drying

Rinse the fabric in cold water until it runs clear. Add 2ml of Synthrapol/Metapex 38/ Colsperse to 1 litre (1¾ pints) of very hot water and immerse the fabric to release any residual dye. It is worth leaving the fabric soaking for 20 minutes. Synthrapol/Metapex 38/Colsperse will also help to prevent back-dyeing or staining, particularly onto light or white areas of fabric. Finally, rinse in cold water until the water runs clear and allow to dry naturally.

Very little dye should appear in the rinsing water. However, it is dependent on the application technique and the actual fabric. If the fabric is coarse, the dye may have difficulty fully penetrating. Finer fabrics will tend to absorb thickened dye very readily, giving an even application.

Once dried and ironed, the fabric will regain its original surface quality.

## Painting techniques

Prepare the fabric by pre-soaking with soda solution, drying and ironing flat. Prepare the thickened dyes as detailed above. Tape the fabric to a piece of stout plastic sheeting, or pin onto a padded printing table, ensuring that it is flat and held firm. Select a range of different brushes such as sponge brushes, synthetic sable brushes and sponge rollers to apply the thickened dye. Make sure, as you apply the thickened dye, that it is fully absorbed into the fabric and not just superficially laying on the surface. Once dry, it is possible to apply direct dye to give softer, more fluid colour application. Be aware that wet thickened dye next to direct dye may cause it to bleed. However, painting thin dye over a dry thickened dye can alter the original colour.

*Below: Thickened and thin dye used in combination on silk dupion, in a design developed from boat ideas.*

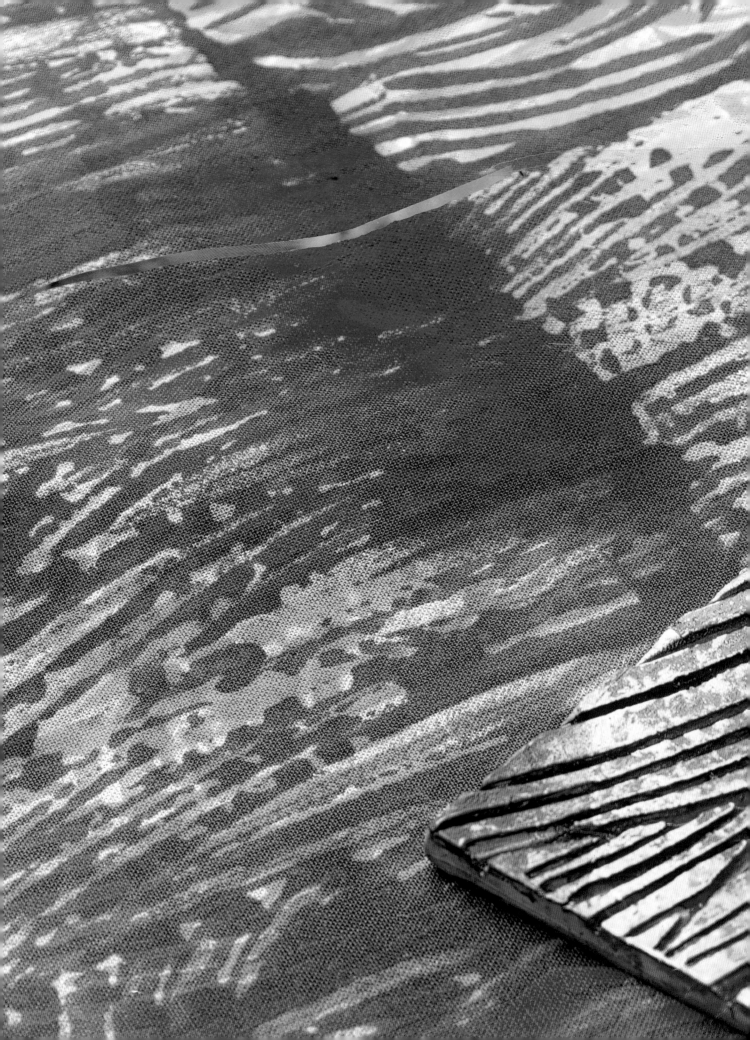

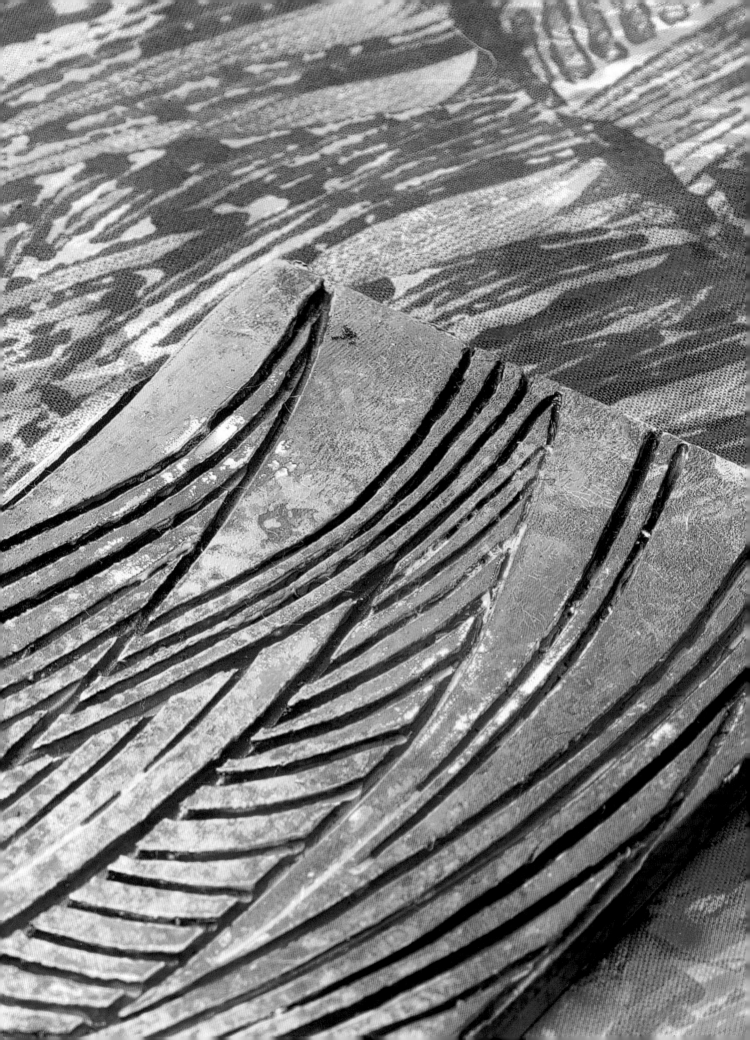

*Previous pages: Cotton calico repeatedly printed with thickened dye using a hand-cut print block made from Speedy-Stamp.*

*Above: Block printing using thickened dye on silk noil.*

## Printing techniques

Use a smooth-faced fabric, such as cotton poplin or sateen, viscose satin or very fine linen. Prepare the fabric by pre-soaking in soda solution or by adding sodium bicarbonate to the thickened dye. Pin the fabric tightly to a flat blanket or padded printing top, which will keep the fabric in place when lifting the coated block or monoprinting plate or other printing equipment. Remember, if a number of overprints are likely, use Manutex F700 (Sodium Alginate F).

**Block printing** Always lay the printing block face up on the table when coating it with thickened dye rather than holding it in your hand. Give the block an even distribution of thickened dye, remembering that you are printing with a transparent colour. Apply the thickened dye with a print roller or foam brush. Do not press too hard as you need the thickened dye on the surface of the block, not driven into the negative edges of your design.

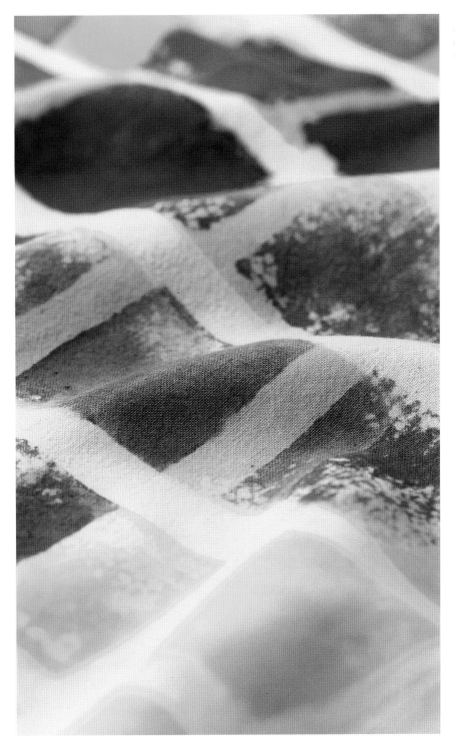

*Left:* Cotton calico printed with a square expanded sponge using thickened dye.

**Patterned foam print rollers** Place the thickened dye into a shallow tray. Make sure that the roller is evenly coated but take care not to press the roller too hard and saturate it with thickened dye.

**Sponges and expanding sponge** These will print very well using thickened dye because the texture and the surface pattern can often be seen. In this way areas of textural printing can be obtained depending on how hard the sponge is pressed into the fabric surface. A simple square piece of sponge can be used repeatedly with different colours, overlaid to create secondary colours and varying density of colour.

*Right:* Fabrics screen-printed using thickened dye, one with direct painting added.

**Stencilling** Cut the stencil from a toughened plastic sheet or acetate. Hold the stencil firmly in position and apply the thickened dye using a sponge brush in an upright position, thus preventing the thickened dye from seeping under the edge of the stencil. Plan the placing of the stencil in advance to avoid having to lay it on a wet area of fabric. Consider using the stencil creatively: make a monoprint with the excess thickened dye left on the top of the stencil by turning the stencil over and pressing the colour onto the fabric.

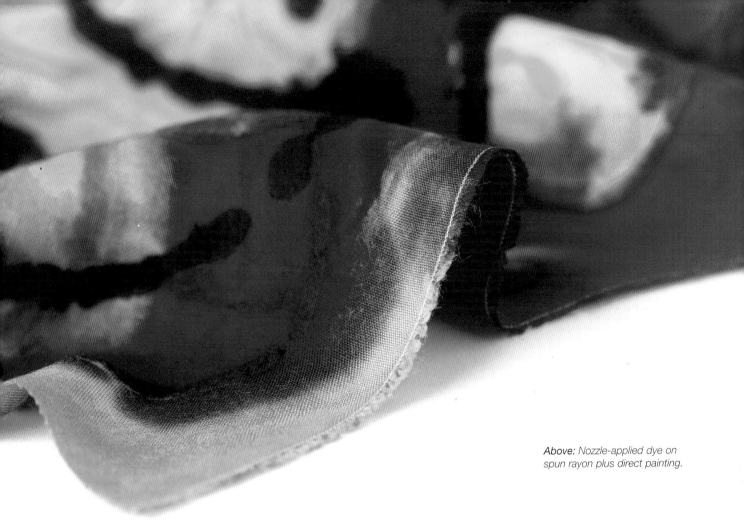

*Above: Nozzle-applied dye on spun rayon plus direct painting.*

**Screen printing** It is possible to produce simple screen prints using a basic cartridge-paper mask. Screen printing will give crisp images and fine, precise lines as well as an even density of print colour. Plan the printing in order to avoid placing the screen on an area that has recently been printed.

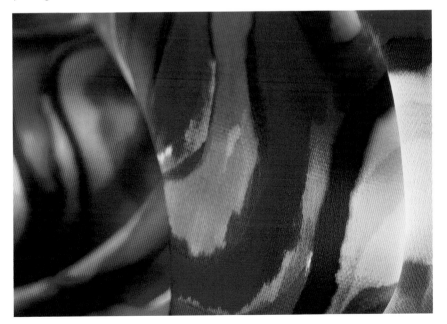

*Left: Thickened dye applied with a nozzle bottle to silk viscose satin.*

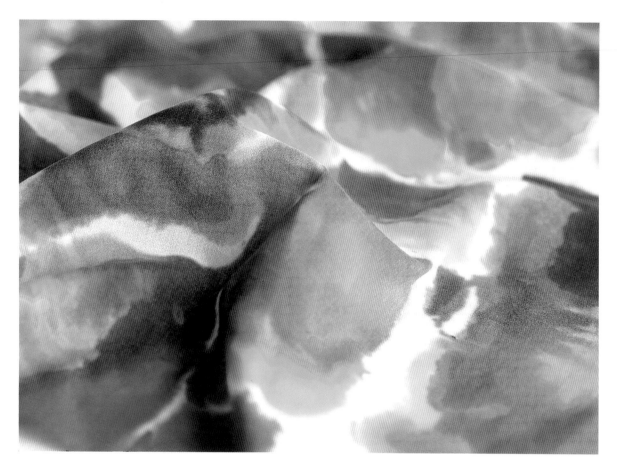

*Above: Direct painting using uncoloured Manutex as a resist, based on a design inspired by a Scottish wall.*

**Direct application** Using a range of different-sized nozzle bottles and applicators you can draw straight onto the fabric. This method gives freedom to those who like to use hand drawing or want to add fine additional detail to a fabric.

**Manutex as a resist** Uncoloured Manutex can be applied to a fabric to prevent other colours penetrating. Apply the Manutex to the fabric, ensuring that it has been fully absorbed and is totally dry before adding any application of dye. The dye will absorb across the fabric, up to the dry resist and, provided it is not too wet, stop. However, if further dye or thickened dye is painted on top of the dry Manutex, it may absorb the colour.

With experience and understanding of colour mixing, wonderful effects can be achieved by repeated applications of thickened dye and thin dyes.

*Opposite page: Length of silk noil painted with thickened dye and additional applications of thin dye.*

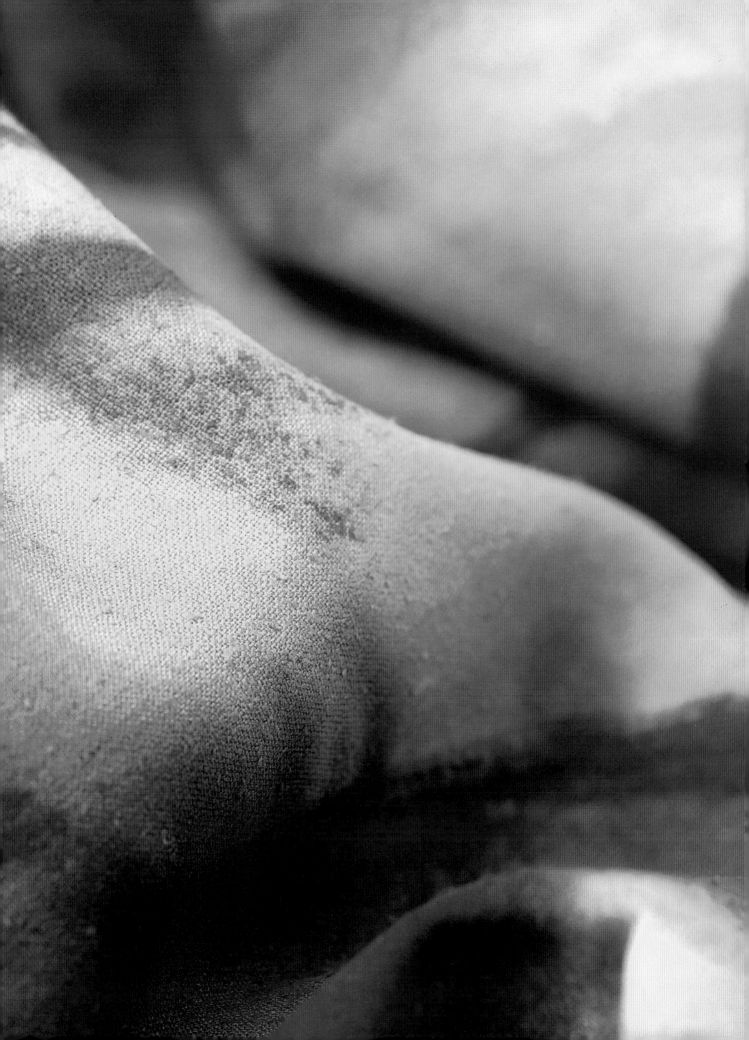

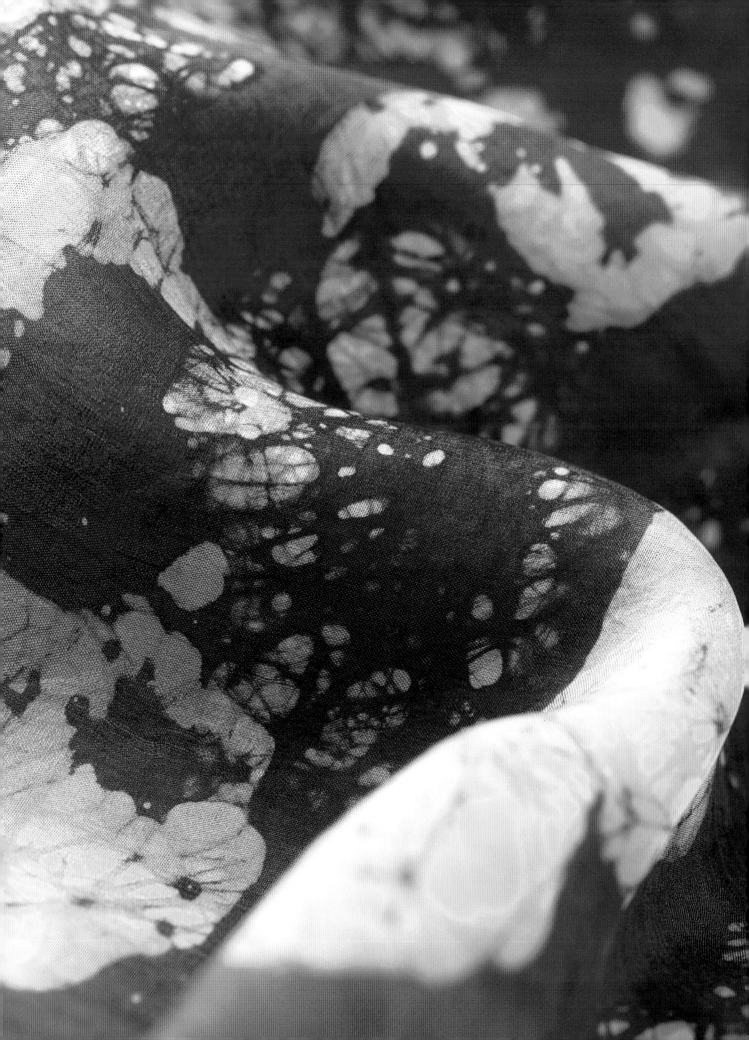

# Chapter Six
## *Resists*

*The logical development of the control of dye is to use resists to create particular patterns or textural effects. Resists will prevent the dye from absorbing into certain areas of the undyed cloth. Traditionally, resists have included wax, mud, starch, flour, cassava starch, rice flour and potato dextrin. This process needs practice and sensitivity, knowledge of the absorbency of different fabrics and fibres and skilled application of the resists and the actual dyes.*

## Useful tips for using resists

Whatever resist is being used the following points must be considered.

- The weight, weave and fibre of the fabric.
- The type of pattern required and the adhesive qualities of the chosen resist.
- The quantity of liquid in the dyes.
- The weather. Paste resists need to be allowed to dry naturally. Warm, sunny weather is good, but if the paste dries too quickly resists can flake off. If the weather is cold and damp, the pastes are slow to dry, sometimes starting to grow moulds!

# Flour paste

Flour paste is the most accessible resist material. It is easy to mix, and as it is a food there is no need to worry about any hidden dangers.

## Recipe for flour paste

- 125g (4½oz) plain flour
- 130ml (¼ pint) water

Place the flour into a mixing bowl and make a well in the centre. Gradually add the water, stirring it into the flour and making a smooth paste with each addition of water. Eventually the flour should be smooth with an even consistency. It should spread easily with a knife or spatula and adhere to the fabric.

## Preparation of fabric

*Page 100: Detail of silk habotai repeatedly waxed and bucket-dyed.*

*Opposite page: Stencilled flour paste in a zigzag pattern, dried and not dyed.*

Initially select close-woven fine fabrics that will not pull or pucker when drawing on the surface. Lay the pressed fabric onto a firm, flat piece of plastic sheeting and tape it into position with masking tape, at least on two sides so that it is reasonably taut and stable. The fabric could alternatively be stretched on a wooden frame such as a silk-painting frame, although this sometimes makes it difficult to draw into the flour paste.

## Application of flour paste

Always remember the resist area is where the paste is applied. Spread the paste evenly with a palette knife, spatula or squeegee. Make sure the paste adheres well to the fabric surface. You need to do this fairly rapidly as the fabric will immediately start to absorb the water from the paste.

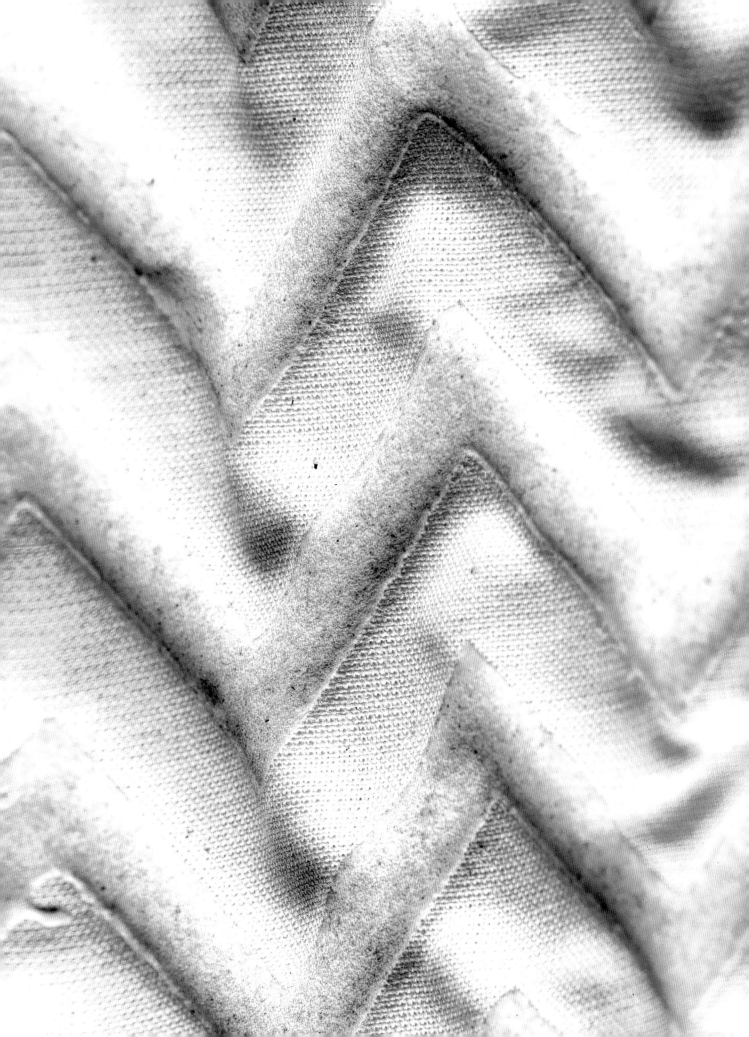

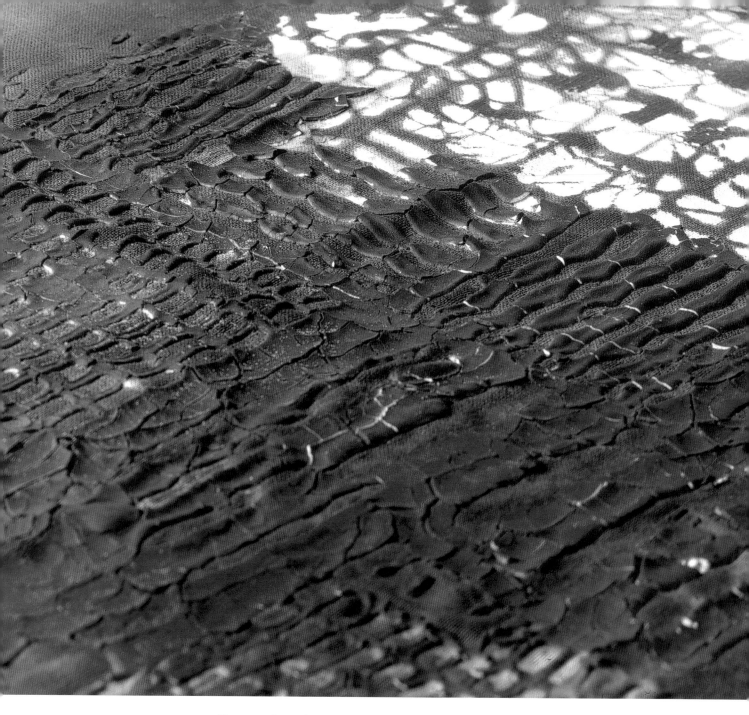

*Above: Flour paste on linen impressed and dyed. Also shows an area where flour paste has been removed.*

*Opposite page: Flour paste fabric using zigzag stencil design, dyed, with the flour paste removed.*

## Patterning the flour paste

As soon as the fabric is evenly covered, draw patterns into the paste with a flat, blunt tool, stick, grouting tool or comb. Pull back the flour paste from the fabric surface using short, firm movements or by impressing items into the paste. When the patterning is complete leave the wet fabric to dry flat in a warm place. Cracks will appear in the paste as it dries; this is all part of the effect of this technique.

Alternatively, you could use a stencil, which is an easy and very successful technique. Spread the flour paste across the stencil, making sure you cover the area evenly. Use both hands to lift the stencil to ensure the image does not get smudged. Plan how the stencils are to be placed on the fabric in order to avoid placing them on top of wet areas. Leave to dry flat, having removed the stencils.

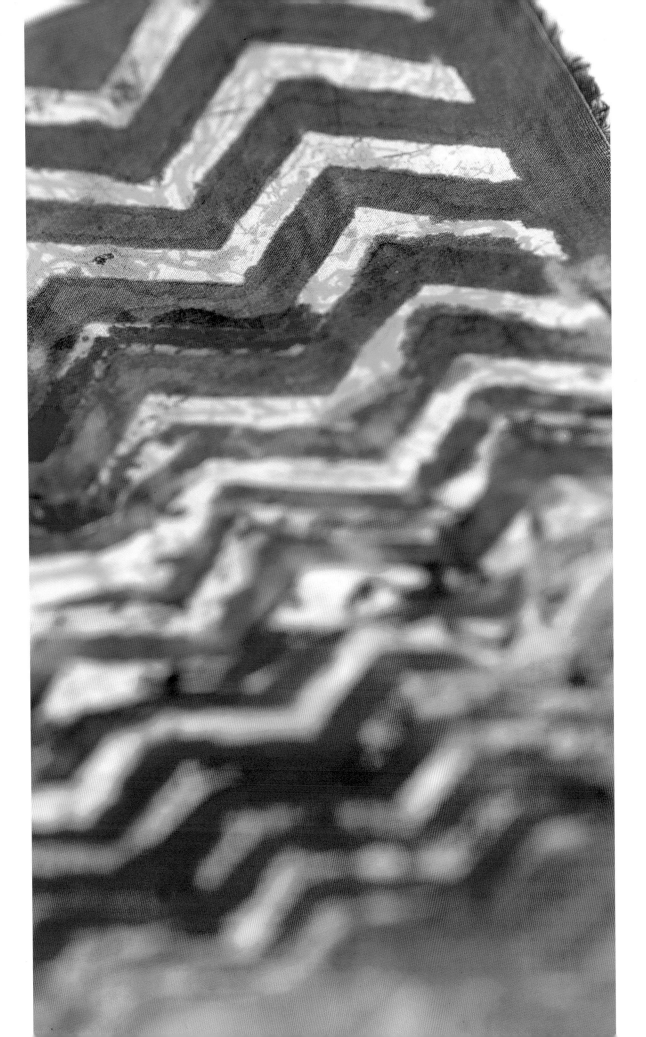

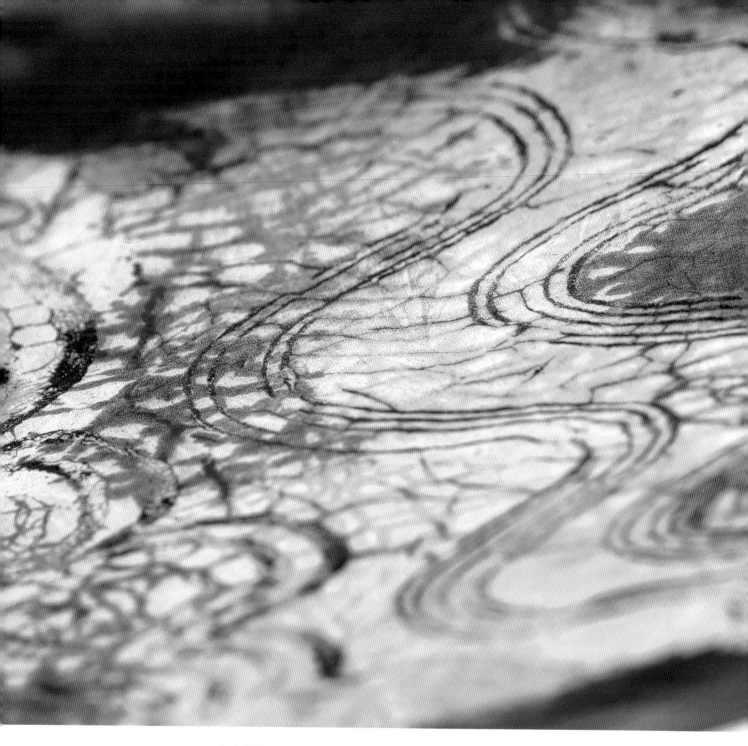

*Above: Flour paste on cotton
poplin, with marks drawn into it
with combs, then dyed and
paste removed to reveal the
dyed areas.*

## Addition of dye

Both thickened and unthickened dye can be used to colour fabrics that have
been patterned with flour paste. Carefully paint the surface with dye, making sure
that the colour covers all the exposed fabric. When painting over the flour paste
watch how the dye is absorbed through the cracks. Care must be taken not to
flood the resist with too much liquid dye. Thickened dye can also be applied if
thin dye seems to be absorbing too quickly into the fabric. The choice of dye
type is dependent on how quickly the fabric absorbs the dye. If the fabric does
get flooded with one colour, let it dry and then gently apply another colour.
Remember that every piece will be unique and there will always be some way to
adjust the colouring.

## Fixing

If you have used thickened dye it will be necessary to heat fix the fabric (see page 90). Direct dye will have already fibre-reacted with the fabric.

## Removal of the paste

Either of the following methods is successful at removing the paste. The decision about which one to use depends very much on the thickness of the fabric and the facilities available for washing and cleaning.

**Method 1** Briefly lay the fabric in a sink of water to moisten the paste. Then lay it on a plastic sheet and with a round-bladed knife gently scrap off the paste. Rinse, dry and iron.

**Method 2** Wearing a dust mask, hold the fabric over a bin and gently rub the two sides together, allowing the paste to flake off. (The flour paste will contain dry dye and can be quite messy.) When most of the paste has gone, gently soak the fabric in cold water to remove any remaining flour. Rinse, dry and iron.

*Left: Flour paste on cotton, impressed with a simple printing block, dried, then dyed, then paste removed.*

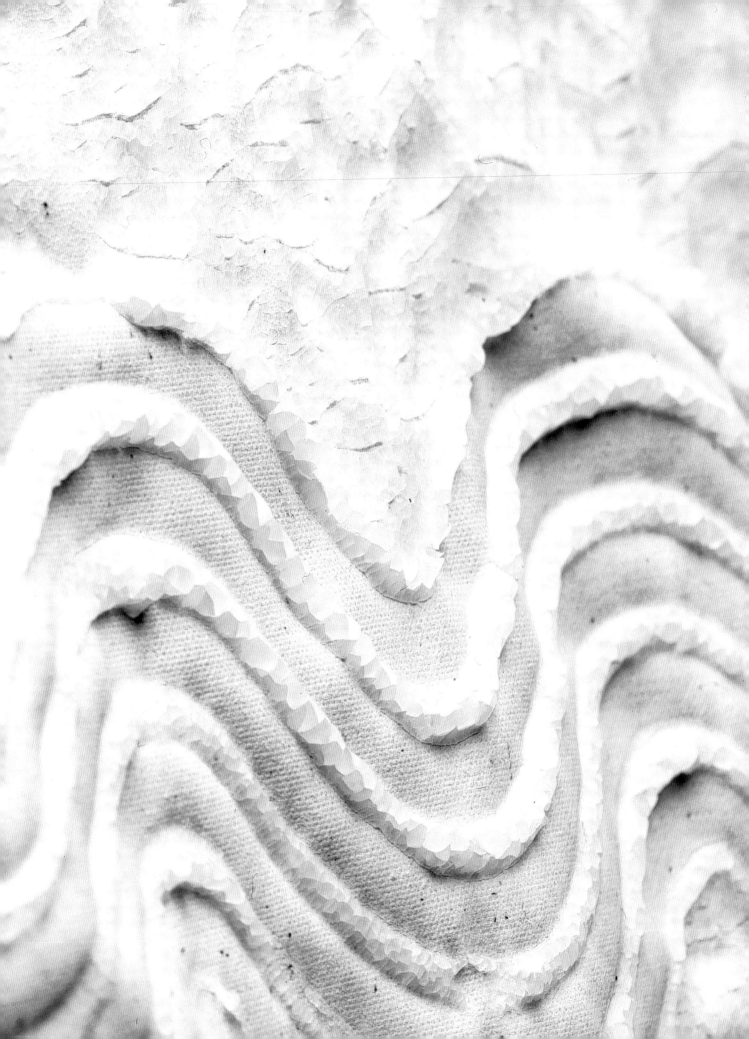

# Potato dextrin

This can be easily obtained from dye suppliers and will give a quick but very different form of resist pattern.

## Recipe for making up potato dextrin
- 240g (10oz) potato dextrin
- 237ml (⅜ pint) boiling water

Sprinkle the potato dextrin into the water, stirring all the time until it is smooth.

## Preparation of fabric
Initially select close-woven, fine fabrics that will be easy to stretch and will not pull or pucker. Lay the pressed fabric onto a firm, flat piece of plastic sheeting and tape it into position with masking tape on at least two sides so that it is reasonably taut and stable. Alternatively, stretch the fabric onto a wooden frame: this often works very successfully with potato dextrin.

## Application
Spread the potato dextrin across the fabric as quickly as possible using a squeegee, spatula or palette knife to give an even coating. Draw into the surface for further patterning, remembering that potato dextrin gives a fine crackled effect across the surface when dry. Larger crackled patterns can be created where the potato dextrin is applied more thickly. Leave the fabric to dry in a warm, airy space. The drying time varies, due to the thickness of application, weight and type of fabric as well as weather conditions. As the paste dries a fine, even crackle develops across the fabric, and thinner areas begin to crack into a fine crazing, as shown above.

*Opposite page: Potato dextrin applied, drawn into while wet with a grouting tool, and left to dry undyed.*

109

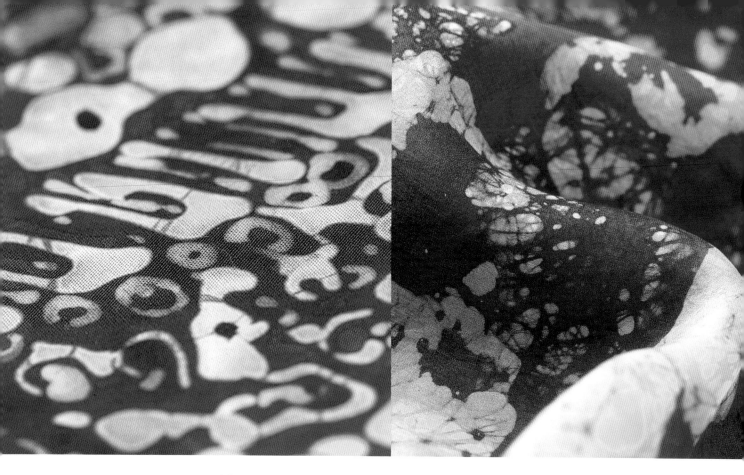

*Above left: Cotton fabric with layers of wax, repeatedly dyed, rewaxed and dye-painted.*

*Above right: Silk habotai, waxed and repeatedly immersion dyed and rewaxed.*

## Masks

Both flour paste and potato dextrin can be applied over masks that have been placed in order to create voided areas on the fabric. Masks can be made from masking tape, sticky-backed plastic or freezer paper.

## Addition of dye

It is advisable to select a thickened dye for the initial application. Potato dextrin seems to absorb thin dye very easily, thus colouring the areas that should be resisted. Further applications of just dye can be added at a later stage when you have acquired sufficient knowledge and experience of how the dye is responding to your fabric and the resist.

Prepare a number of thickened dyes and select a range of sponge brushes or absorbent paintbrushes (painting potato dextrin can be very abrasive on brushes). Remove the tape and lay it onto the polythene. Carefully apply a brush of colour to the edge of the potato dextrin, then quickly view the reverse side to check how the dye is absorbed. It may be necessary to have a very light touch, just stroking the surface of the fabric and yet letting the dye penetrate into the cracks. Allow the fabric to dry and then inspect the result from the reverse. This will give an impression of what will be dyed when all the paste is removed. The fabric takes on a wonderful 3-D quality at this stage and becomes very beautiful in its own right.

## Fixing

If you have used thickened dye it will be necessary to heat fix the fabric (see page 90). Direct dye will have fibre reacted with the fabric already.

### Removal of potato dextrin

Potato dextrin is very brittle and will usually just flake off the surface. Alternatively, lay the fabric in a deep tray or bath and wash with water from a garden hose. The potato dextrin dissolves quite readily and is easily washed off. Wash, dry and iron the fabric.

### Further ideas

Flour and potato dextrin pastes can be used with other fabric-colouring mediums such as fabric paints. They can also be used in combination with the discharging techniques outlined in the next chapter.

## Wax resists

It would be unthinkable not to mention wax resists or batik when considering resists and dyeing. The use of wax is one of the most exciting and well-practised resist techniques. Batik can be combined with direct-dye painting as well as immersion dyeing. It can also be used in combination with techniques such as space dyeing and pattern dyeing to protect areas of fabric when over-dyeing. Wax must be heated in a proper wax pot that is insulated and has a thermostatic control. Different waxes will give different qualities of crackle and liquid application. Tools that can be used to apply the wax range from Tjantings to brushes and even coarse sponges. There are many excellent and very thorough books available that cover all the different aspects of wax resist. It is well worth studying them and considering using them in conjunction with some of the techniques outlined in this book.

*Below:* Cotton fabric Procion MX dyed, waxed, crackled then bleached.

# Chapter Seven
## *Bleaching and discharging dye*

*Discharging is the term used for bleaching out Procion MX dye with a thickened paste – the stripping of the dyed colour from a fabric. Depending on the dyed base colour, the discharging will bleach to a variety of colours, ranging from almost white to a paler shade of the original colour.*

## Health and safety advice

Both discharge paste and bleach must be treated with care.

■ Always wear protective gloves, protective clothing, and work in a well-ventilated area.

■ It is advisable to wear a fume mask when discharging with heat. Fumes given off can be very irritating to some people: please be sensitive to the needs of others when using these methods.

## Procion MX dye colours and discharge

*Page 112: Black discharge velvet, plain discharged then Procion MX dyed.*

Certain pure Procion MX colours discharge very adequately, such as yellows, browns, magenta, scarlet and black, whereas blues, greens and turquoise tend to discharge to a paler version of the original colour. It is advisable to test your chosen colours for yourself.

*Below: Procion MX dyed cotton velvet with discharge paste applied with a sponge brush.*

The colours will also vary on different fibres due to the absorbency of the different dyes and colour mixes.

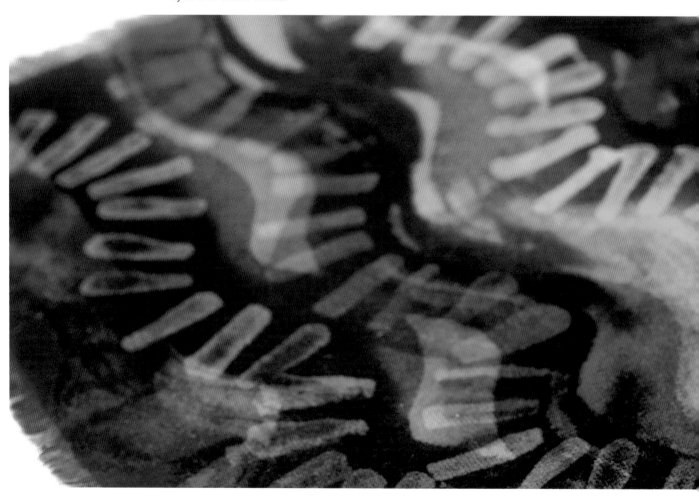

The chart indicates the colour achieved when discharging and bleaching a basic set of 12 Procion MX colours.

**Colours achieved through discharging and bleaching**

| Dyed colour & fibre | Discharge paste | Bleach |
| --- | --- | --- |
| Lemon yellow cotton | White | White |
| Lemon yellow linen | White | White |
| Lemon yellow rayon | White | White |
| Golden yellow cotton | Light gold | Slight colour left |
| Golden yellow linen | Light coffee | Slight colour left |
| Golden yellow rayon | Light coffee | Slight colour left |
| Rust orange cotton | Light rust | Light gold |
| Rust orange linen | Light orange | Light gold |
| Rust orange rayon | Very light orange | Light orange |
| Orange cotton | White | White |
| Orange linen | White | White |
| Orange rayon | White | White |
| Scarlet cotton | Coffee | Light orange |
| Scarlet linen | Coffee | Light orange |
| Scarlet rayon | Coffee | Light orange |
| Magenta cotton | Green coffee | White |
| Magenta linen | Green coffee | White |
| Magenta rayon | Green coffee | White |
| Violet cotton | Bluish grey | White |
| Violet linen | Dark coffee | White |
| Violet rayon | Grey | White |
| Medium blue cotton | Bluish brown | Very slightly off-white |
| Medium blue linen | Tan/brown | Very slightly off-white |
| Medium blue rayon | Grey/brown | Very slightly off-white |
| Turquoise cotton | Light turquoise | Slightly turquoise |
| Turquoise linen | Light turquoise | White |
| Turquoise rayon | Light turquoise | Pale turquoise |
| Emerald green cotton | Pale turquoise | White |
| Emerald green linen | Light turquoise | White |
| Emerald green rayon | Pale turquoise | White |
| Brown rose cotton | Flesh colour | Light brown |
| Brown rose linen | Beige | Light brown |
| Brown rose rayon | Light beige | Light brown |
| Jet black cotton | Very light grey | Off-white |
| Jet black linen | Beige | Cream |
| Jet black rayon | Greyer beige | Cream |

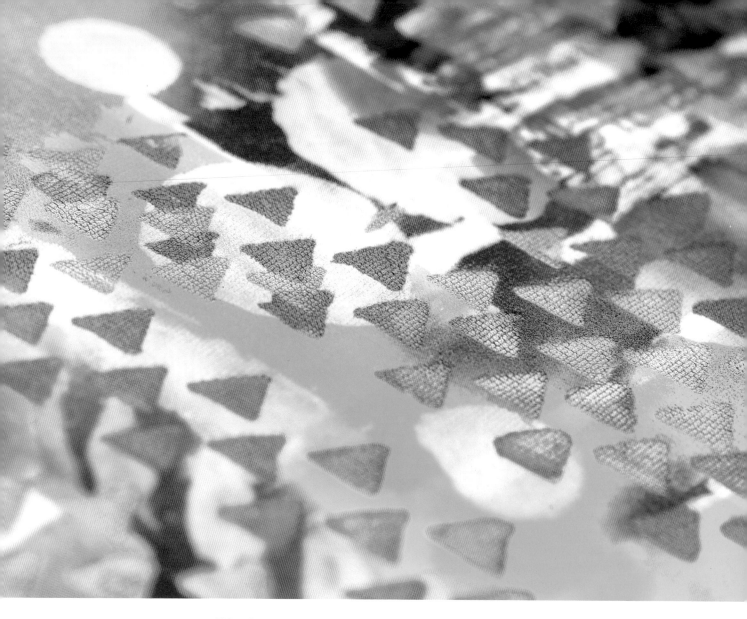

*Above: Cotton velvet Procion
MX dyed, discharged, then
further discharged plus fabric
paint applied through a stencil.*

## Discharge paste

Discharge paste is a pre-mixed white paste that can be applied to any Procion MX dyed and washed fabric. Jacquard discharge paste can be used directly from the bottle. It is also possible to buy the ingredients to make your own discharge paste from specialist suppliers.

The paste can be applied with brushes, sponges, print blocks or stencils and print rollers.

Once fully dry the paste can be discharged using a hot steam iron. It is important to apply plenty of steam to the fabric and make sure that the steam has penetrated right through the dry paste. Colour alteration is dependent on the original dyed colour and the fibre of the fabric.

Once discharged the fabric can be washed and further additions of dye can be applied, if desired.

There are a number of creative and imaginative ways that discharge paste can be used to give unpredictable and unique effects.

## Use of discharge paste alone

Apply the discharge paste to washed, dyed fabric by any suitable means –
painting or printing, using a stencil or roller. Allow to dry naturally or use a
hairdryer. Once fully dry, heat the iron to the lowest steam setting. Iron on the
right side, applying as much steam as possible to the discharged areas. Once all
the dye has been discharged, wash the fabric to remove any residue discharge
paste and smell.

## Application of discharge paste and the simultaneous
## addition of an alternative colour

Mix the discharge paste with any heat-fixed fabric paints, silk paints or printing
pigments, not Procion MX dyes. To ensure a strong colour make sure that there
is at least 50 per cent fabric colour added to the discharge paste. Apply the
mixed colour to the fabric by painting or printing, using stencils, sponges or a
roller. Once dried, steam iron as before and the fabric paint colour will replace
the original dyed colours. The fabric paints will be heat fixed during the
discharging process. Wash the fabric to remove any residual discharge paste
and leave to dry naturally.

## Using discharge fabric

It is possible to purchase prepared dark blue and black discharge fabric from
specialist fabric suppliers. Very dramatic and striking discharged and dyed effects
can be created with this fabric.

Apply the discharge paste by painting or printing, using a stencil or roller. Once
dried, remove colour with a steam iron. After discharging is complete, wash the
fabric thoroughly. Apply Procion MX dye colour, mixed for direct dyeing, into the
areas that have been discharged. The remaining black fabric will conceal any
colour bleeding that might have occurred.

*Below left: Black discharge
velvet, plain discharged then
Procion MX dyed.*

*Below right: Procion MX dyed
silk noil, plain discharged with
shaped sponge, further
discharged plus fabric painted.*

*Following page: Red-dyed
velvet, stencilled with discharge
paste and fabric colour.*

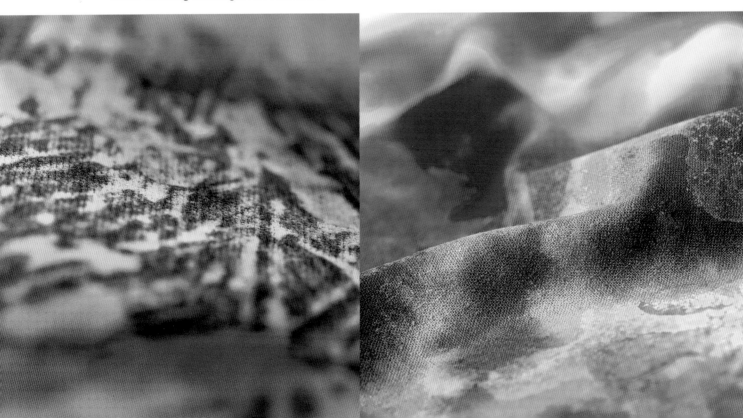

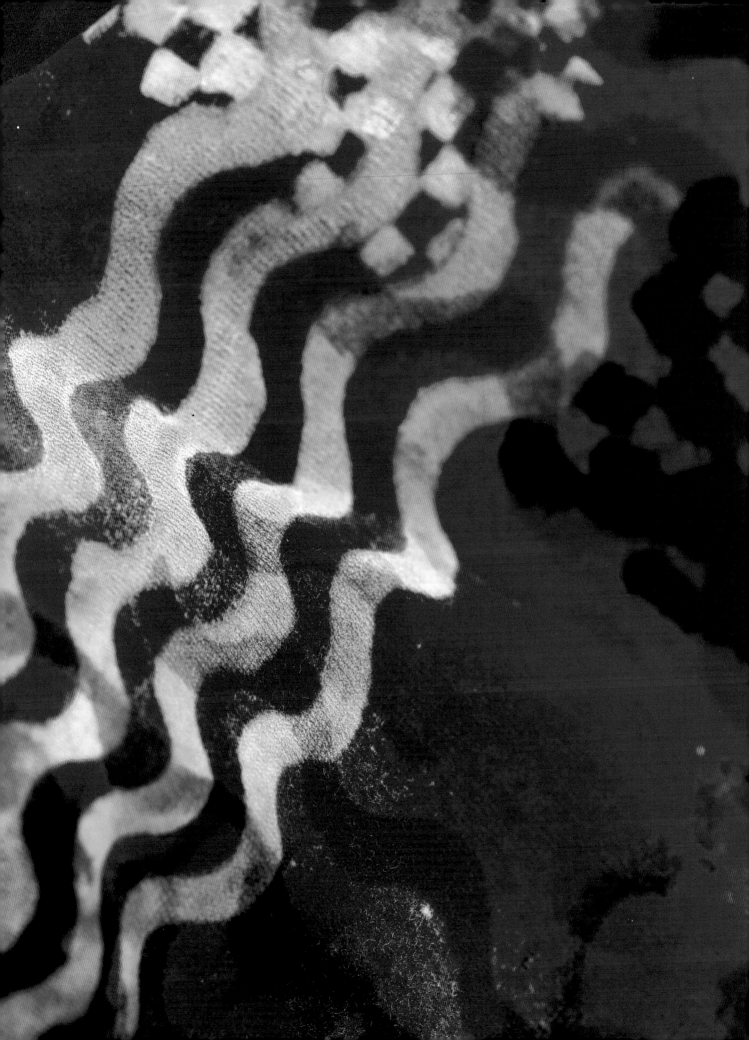

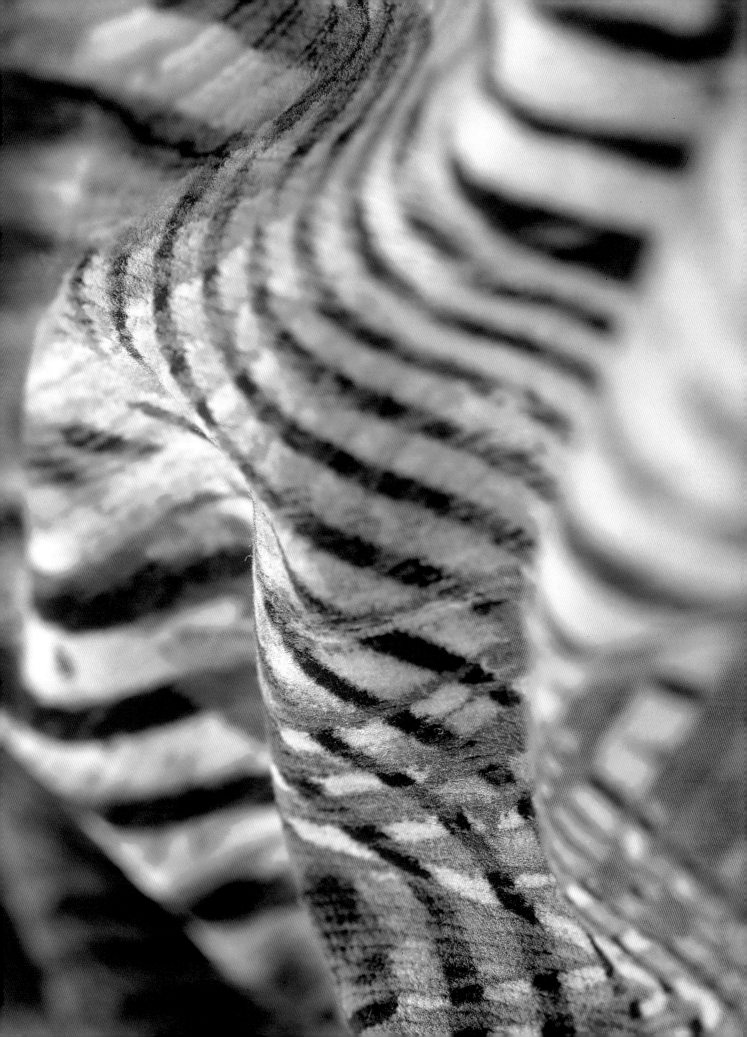

# Bleaching

Bleach can be used to remove Procion MX dye colour. It works on cotton, viscose, rayon and linen but it will rot silk.

## Health and safety advice
Bleach must be used with considerable care.

*Previous page: Black discharge velvet, plain discharged and stencilled. Further discharge and fabric paints were added to put colour back into the fabric.*

*Below: Black Kona cotton stencilled with thickened bleach.*

■ Always wear protective gloves, apron and a face mask. Some bleach has a very strong smell that can become very overpowering if used repeatedly. It is always important to use it in a well-ventilated area.

■ It is essential to neutralize bleach after use. First you must rinse the fabric thoroughly to remove the excess bleach. Then soak the fabric in white vinegar to neutralize it and rinse again in soap and warm water. The fabric should then be thoroughly cleansed.

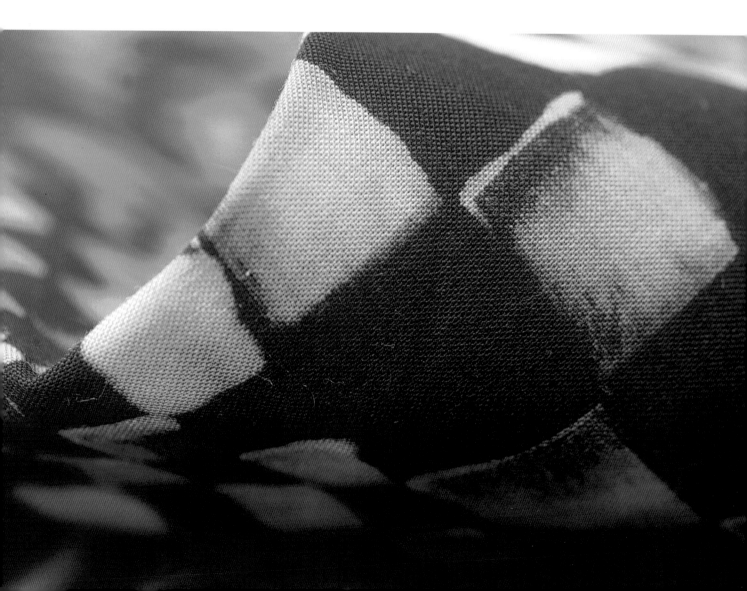

## Considerations

Using bleach to remove dye does have a number of disadvantages.

First, commercial bleaches vary in strength and thickness.

Bleach is more liquid than discharge paste. It is difficult to apply by printing but with care it can be applied through a stencil or with a sponge or brush. It is very easy for the bleach to creep or flood so constant attention is necessary. Be prepared to rinse the fabric rapidly, if necessary.

It is, however, possible to achieve very attractive effects using bleach and in many cases, as outlined on the chart on page 115, it will return the fabric to a white. Experiment with various black fabrics available in fabric shops, as sometimes bleaching will give a beautiful ginger colour, a pink/mauve or a tan colour.

It is possible to use some of the pattern dyeing methods such as rolling and tying, thus restricting the area of fabric that the bleach can reach. This can give random yet organic patterns that can be very attractive as they are or as a basis for further dyeing.

*Below: Silk monoprinted with thickened dye.*

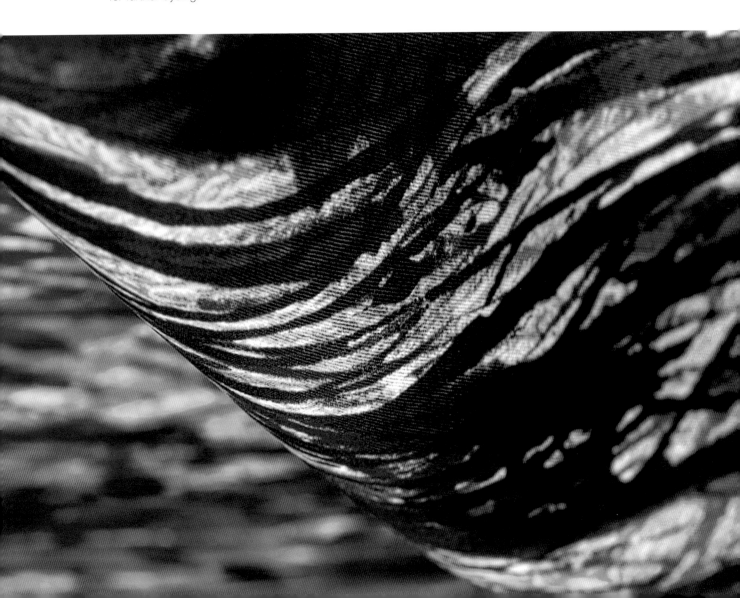

# Devoré – burn-out

Devoré is a technique that is used on mixed-fibre fabrics when one fibre is dissolved by chemicals, leaving the other ground fibre (the basic woven structure). This tends to leave the fabric with a semi-transparent and etched look. Fabrics commonly used are silk/viscose velvet and silk/viscose satin. The viscose (cellulose) is dissolved, leaving the silk with the appearance of a silk organza.

Devoré is a technique that needs to be undertaken with some care, knowledge and experience. The actual paste contains aluminium sulphate, which when heated gives off an acid gas. It is essential to wear a fume mask and to work in a well-ventilated area. The actual dyeing of the fabric should be undertaken after the devoré process is complete.

Despite the precautions that need to be taken, devoré can be a very rewarding process and the resulting fabrics are exquisite and unique.

There are a number of different prepared and semi-prepared devoré packs available. Different dye suppliers offer extremely good packs with instruction leaflets giving detailed guidance for making up the devoré paste. There is also a prepared paste called Fiber Etch that is more costly but comes ready to use from the bottle. It does, however, have a tendency to be slightly more aggressive and can very easily lead to perforated fabrics rather than subtly etched ones. The suppliers for the devoré pastes can be found at the end of the book.

## Application

Before undertaking a large piece of devoré, try out your chosen technique on small pieces of fabric, let them dry and complete the full devoré process. This will show how much devoré paste to apply, how thick and which method will suit the chosen fabric and design.

Prepare the fabric by either pinning it to a padded board or blanket or by taping it to a flat polythene sheet. The fabric needs to be really flat and well ironed.

When using devoré paste on a piled fabric such as silk/viscose velvet always work from the reverse side of the fabric, as it is only necessary to dissolve the fibre where it is attached to the base fabric, rather than the whole pile.

When working on smooth-faced fabrics, such as silk/viscose satin, work from the right side with the paste, applying it to the viscose surface.

## Techniques

Once the paste is mixed it can be applied to the fabric in several different ways. Stencilling works very well with devoré paste. Apply using a small sponge brush, taking care not to allow the paste to seep under the edge of the stencil. The paste can give very crisp lines and clearly defined shapes.

*Opposite page: Close-up of a devoré scarf.*

Monoprinting gives a less repetitive and structured result. Use an acetate or laminated sheet, rather than a glass plate, which can be too heavy for the paste

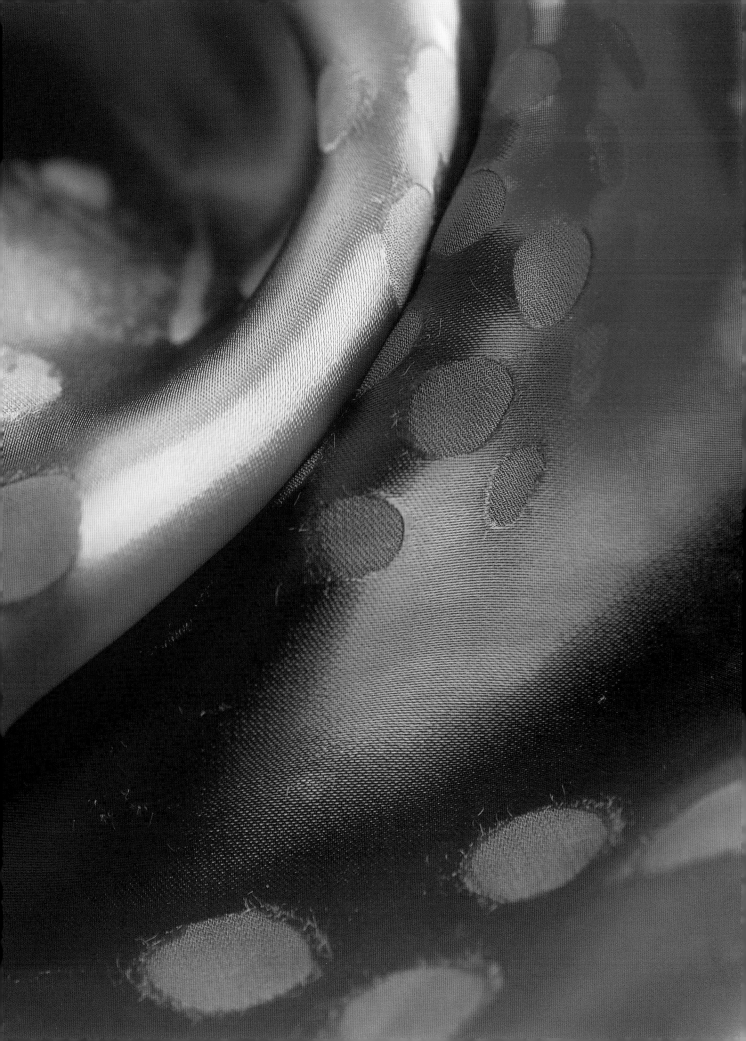

and has a tendency to make it spread too much. Do not apply the paste too thickly to the plate, to prevent heavy and rather clumsy lines after drawing into the surface.

Block printing creates good results, especially using a block cut from lino, Speedy-Stamp or made from string or other materials such as Foamtastic or Fun Foam.

Roller printing can give fine rippling lines when directly applied. A roller impressed across a printing block will also give unusual and distorted patterns.

Applying the devoré paste directly using a nozzle bottle or with a nib needs care to keep the application even. It can be prone to the occasional blob or even to flood. Always begin any line by drawing from some paper so that the line flows smoothly across the fabric.

## Burning process

The paste must be totally dry. (It is sometimes difficult to see the paste once it has dried.)

The paste is activated by controlled use of heat. Do this in a well-ventilated area, preferably with an extractor fan and wearing a fume mask.

The paste can either be activated by baking for 5 minutes at 150°C/gas mark 2 or by pressing with a dry iron. By using an iron the process can be controlled and it is easy to see when the paste is beginning to burn.

Set the iron to a cool setting and begin to iron gradually, adjusting the heat upwards. As the heat starts to affect the dry paste it will change colour from cream to coffee to a dark brown. Caution must be taken when the paste is becoming dark brown not to overheat and burn all the fibres.

Check that the fibres have been destroyed by gently rubbing a small area over a waste bin. The fibres will create a quantity of dust, especially when using velvet, so it is advisable to wash the fabric gently, rubbing the surface in the water to prevent loose fibres filling the air.

## Dyeing

*Opposite page: Various natural undyed fabrics were layered and hand-stitched together. They were then dyed to show how different fibres absorb dye differently. Also shown is a sample of undyed fabric and stitch.*

Once the fabric is fully finished and washed it is possible to dye it using any of the methods outlined in previous chapters. Be aware that the silk and the viscose will take the dye colours differently. Sometimes with careful application two totally different colours can be achieved in juxtaposition.

It is advisable to try out different dyeing techniques on the devoré samples undertaken earlier.

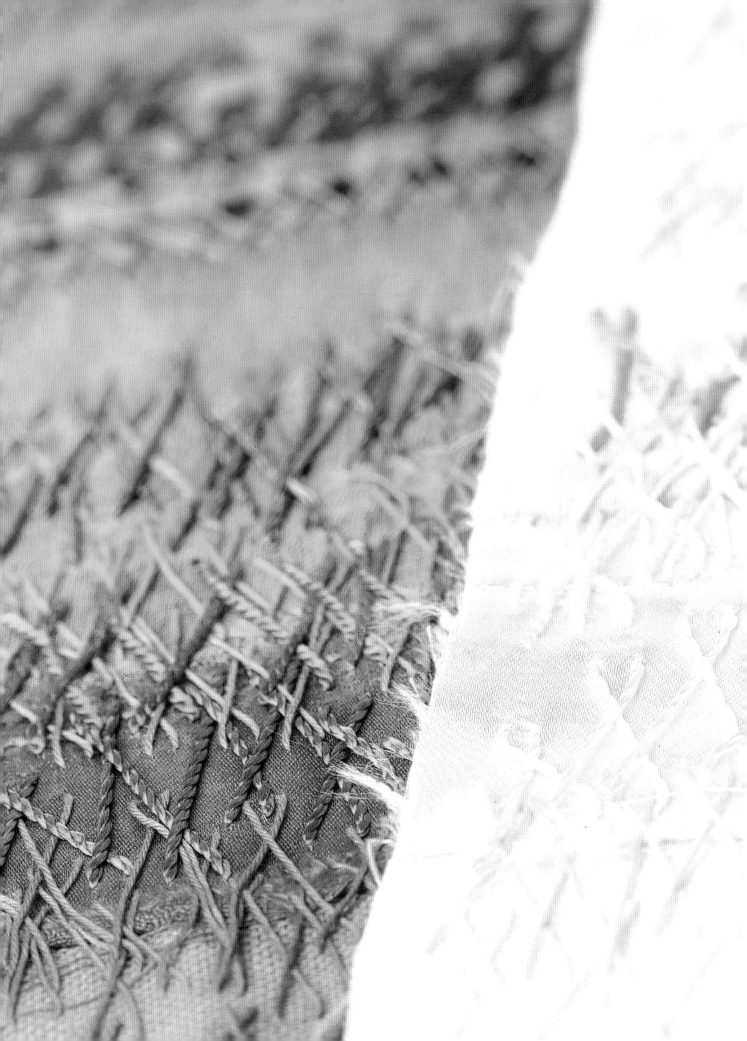

# Acknowledgements

I would like to thank everyone who has encouraged me to write this book, to students who are so enthusiastic, to colleagues such as Viv and Kevin, Gail and Penny, who are so supportive and to Michael for his skilled and professional photography. Finally to Chas, Lucy, Olly, Samuel, Evelyn, Adam, Ali and Jon who continue to support me and enthuse about my manic obsession for colour and fabric!

# Suppliers List

## Dyes

**Art Van Go**
The Studios
1 Stevenage Road
Knebworth
Hertfordshire SG3 6AN
Tel: 01438 814 946
Fax: 01438 816 267
www.artvango.co.uk

*Mail order and shop. Full range of dyeing equipment, brushes, unusual sponge rollers, stencils, palettes, wide range of dyes, auxiliaries, Manutex, potato dextrin, devoré kits, discharge paste, sketchbooks.*

**Colourcraft
(Colours & Adhesives) Ltd**
Unit 5
555 Carlisle Street East
Sheffield
South Yorkshire S4 8DT
Tel: 0114 242 1431
Fax: 0114 243 4844
www.colourcraftltd.com

*Dyes, auxiliaries, discharge and devoré supplies, literature.*

**Kemtex Colours**
Chorley Business and Technology Centre
Buxton Lane
Chorley
Lancashire PR7 6TE
Tel: 01257 230 220
Fax: 01257 230 225
www.kemtex.co.uk

*Dyes, auxiliaries, discharge and devoré supplies, guidance literature.*

## Fabrics

**Whaleys (Bradford) Ltd**
Harris Court
Great Horton
Bradford
West Yorkshire BD7 4EQ
Tel: 01274 576 718
Fax: 01274 521 309
www.whaleys-bradford.ltd.uk

*Extensive range of fabrics suitable for dyeing. Full mail-order service.*

**The Silk Route**
Cross Cottage
Cross Lane
Frimley Green
Surrey GU16 6LN
Tel: 01252 835 781
www.thesilkroute.co.uk

*Mail-order silk fabrics, unusual weaves plus small quantities.*

## Yarns

**Texere Yarns**
College Mill
Barkerend Road
Bradford
West Yorkshire BD1 4AU
Tel: 01274 722 191
www.texereyarns.co.uk

*Wide range of undyed threads, wools and ribbons.*

# USA

## Dyes

**Jacquard Products**
Rupert, Gibbon & Spider
P.O. Box 425
Healdsburg, CA 95448
Tel: 001 800 442 0455
Fax: 001 707 433 4906
www.jacquardproducts.com

*Dyes, discharge paste, Fiber Etch, auxiliaries, potato dextrin, fabrics.*

**Dharma Trading Company**
Box 150916
San Rafael, CA 94915
Tel: 001 800 542 5227
www.dharmatrading.com

*Dyes, auxiliaries, fabrics.*

**Dick Blick**
Box 1267
Galesburg, IL 61402
Tel: 001 800 828 4548
www.dickblick.com

*Art supplies and dyes.*

**Pro Chemical & Dye, Inc**
Box 14
Somerset, MA 02726
Tel: 001 508 676 3838
www.prochemical.com

*Dyes and auxiliaries.*

## Fabrics

**Testfabrics Inc**
PO Box 26
415 Delaware Avenue
West Pittston, PA 18643
Tel: 001 570 603 0432
Fax: 001 570 603 0433
www.testfabrics.com

*Mail-order fabrics.*

**Thai Silks**
252F State Street
Los Altos, CA 94041-2053
Tel: 001 800 722 7455
Fax: 001 650 948 3426
www.thaisilks.com

*Mail-order silk fabrics.*

# CANADA

**Maiwa Handprints**
6-1666 Johnston Street
Granville Island
Vancouver, BC
V6H 2SZ
Tel: 001 604 669 3939
Fax: 001 604 669 0609
www.maiwa.com

*Dyes, auxiliaries, fabrics.*

**G&S Dyes**
250 Dundas Street W., Unit 8
Toronto, Ontario
M5T 2ZS
Tel: 001 800 596 0550
Fax: 001 800 596 0493
www.gsdye.com

*Dyes and auxiliaries.*

# Index